IMAGES
of America

AUTO RACING IN
CHARLOTTE AND THE
CAROLINA PIEDMONT

IMAGES
of America

AUTO RACING IN CHARLOTTE AND THE CAROLINA PIEDMONT

Marc P. Singer and Ryan L. Sumner

ARCADIA
PUBLISHING

Published by Arcadia Publishing
Charleston, South Carolina

Printed in the United States of America

Library of Congress Catalog Card Number: 2003100675

For all general information contact Arcadia Publishing at:
Telephone 843-853-2070
Fax 843-853-0044
E-mail sales@arcadiapublishing.com
For customer service and orders:
Toll-Free 1-888-313-2665

Visit us on the Internet at www.arcadiapublishing.com

CONTENTS

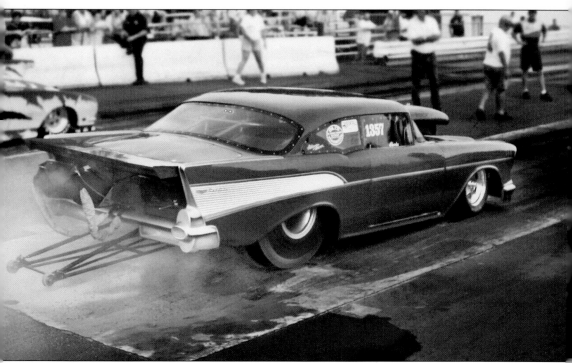

The "Test and Tune" open track competition at Mooresville Dragway allows drag racers to bring cars of any type, regardless of how much they have been modified, and race them against any and all competition. (Photo by Andy Mooney.)

INTRODUCTION

For many people around the country, Charlotte is synonymous with auto racing. They're probably thinking of the Winston Cup racing series at Lowe's Motor Speedway, where the most famous stock car drivers in the world battle it out three times a year on what for many is their home turf. But Charlotte's connection to racing goes much farther than the Winston Cup. Indeed, Lowe's Motor Speedway is so successful because it is at the center of a racing culture that made it possible, and even necessary, in the first place. In the past century, Charlotte and the surrounding Carolina Piedmont have been home to every kind of auto racing, from stock cars to drag racing to soapbox derbies to slot cars. Lowe's represents the most visible aspect of racing in the Piedmont today, but it is just one of many forms that are practically native to the place.

People from around the country are right to link Charlotte with racing—but they don't know how right they are. Historically, Charlotteans have taken a real pride in their cars, and their relationship with their vehicles has been deep and complex. Perhaps the history of the region itself has something to do with that. The Piedmont was historically poor, as was most of the South, but it was one of the first parts of the region to embrace the idea of the New South— a powerful view of social change, political progress, economic development, and industry. Transportation—and the automobile in particular since it represented industrial progress— was a powerful symbol of the Piedmont's embrace of New South values. People needed good cars both for the work they did and to keep up with the rapidly expanding development of the region.

Naturally, when people who were proud of their cars met others with similar feelings, it was only a short step from there to racing. Automobiles allowed Charlotteans to combine their forward-looking mastery of technology with more elemental, fundamental passions. That's what auto racing is all about. Who's got the fastest car? Whose tractor can pull the heaviest load? Who has built the most reliable engine? Only one way to find out—and many did.

Racing, as we hope to show in these pages, has a long and rich history in Charlotte and the surrounding region. This car culture helped bring the Carolina Piedmont together in many ways. It brought people into the city to race their cars, but as racing became more of an established sport, it also expanded the circle of competitors and brought people together who simply shared a love of automobiles. As this passion for cars grew, it translated itself into more practical concerns, such as highway and road building. And this understanding of and love for the automobile cemented the interdependent relationship between the city and the rest if the Piedmont in many complex ways.

As Larry Thomas of Concord Motorsport Park told us, racing is in our blood here. "Auto racing is to Charlotte as hockey is to Canada," he said. "You grow up with it, you're immersed in it, from your youngest age." That idea is reflected in this book. In these pages you will see Charlotteans and residents of the Piedmont, of all ages, from all walks of life, doing what they love: racing their cars.

One

RIDING THE BOARDS

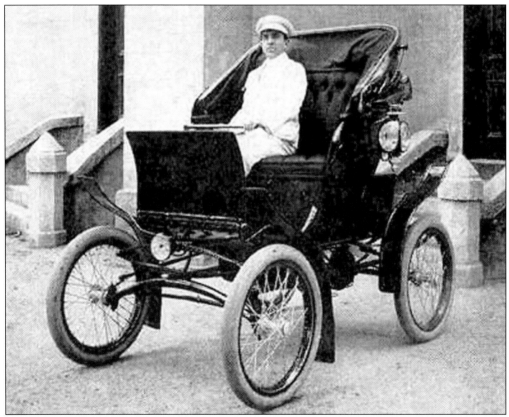

Charlottean Osmond Barringer became the first Southerner to own a car when he took possession of a pair of steam-driven Locomobiles shipped by boxcar from Bridgeport, Connecticut in October 1900. These horseless carriages had more in common with bicycles than with modern cars. Here he is seen in a *c.* 1902 Baker Electric Automobile. His interest in automobiles would later make him a pioneer in Charlotte's racing history. (Charlotte-Mecklenburg Historic Landmarks Commission.)

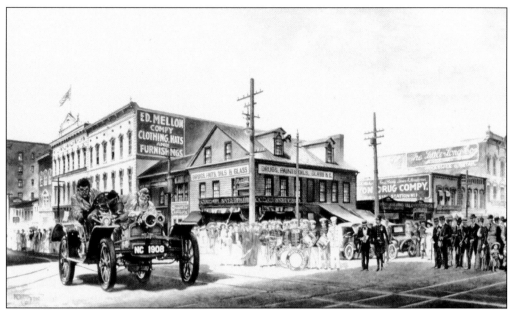

In this Werner Willis painting set in 1908 Charlotte, a driver and his mechanic are all business as their Sizaire takes a turn through "The Square," where Trade and Tryon Streets intersect. Considering the turnout of police, a band, and a fair number of Charlotte's more respectable citizens, it is clear that this exhibition was a major event. Since Charlotte city directories do not record anyone in town owning a car until 1904, seeing an automobile pushed to the limit would have been quite a novelty. (Werner Willis.)

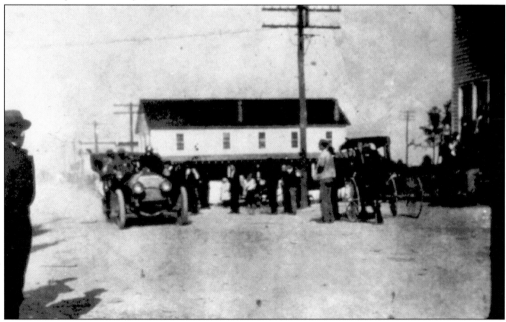

Cabarrus County, today home to several tracks, got the racing bug early on. This 1910 photograph shows one participant in a race through the streets of Kannapolis, a town that was established only four years before. The white building in the background still stands. (History Room, Charles A. Cannon Memorial Library, Kannapolis Branch.)

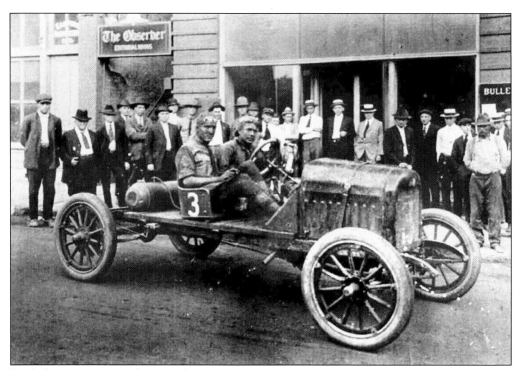

Fresh from an open road race, a dusty driver and mechanic pause in front of the *Charlotte Observer* building on South Church Street in 1919. In the early days, it was common for a driver to be accompanied by his mechanic, especially on long distance races. More often than not, a mechanic's skills at extinguishing fires came in handy. Racing cars, whose top speed in 1919 rarely exceeded 100 mph, often disintegrated or exploded when drivers tried to push them beyond that. (Robinson-Spangler Carolina Room, Public Library of Charlotte and Mecklenburg County.)

By the 1920s, Osmond Barringer (right) was a very successful car dealer and local businessman. Inspired by seeing a race in Indianapolis, he and C. Lane Etheredge, along with banker B.D. Heath, formed a corporation to build a track and bring auto racing to Charlotte. After issuing $230,000 in stock and securing $150,000 in bonds, the group began construction of the premier racing facility in the South. Barringer became the general manager. (*Charlotte Observer*.)

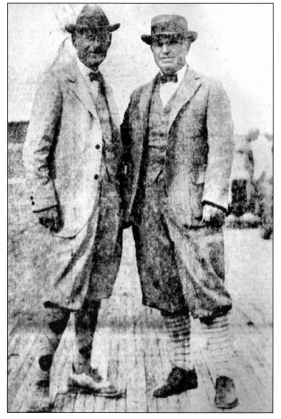

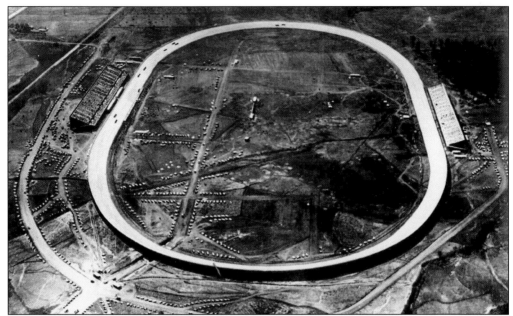

The Charlotte Speedway held its first event in October 1924 and operated through September 1927. The one-and-a-quarter-mile oval track was constructed of pine and cypress planks and banked 40 degrees in the turns. Seven major events of national import were held here, including three of the twelve major races on the Championship Auto Racing schedule in 1926. (Robinson-Spangler Carolina Room, Public Library of Charlotte and Mecklenburg County.)

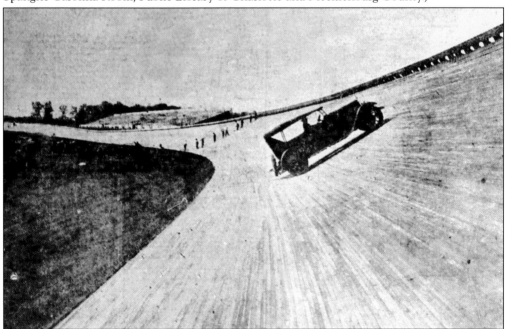

The high banking of the turns is apparent in this photograph depicting the speedway's surface. The steeper a track was banked, the faster cars could fly around it. At 40 degrees, the rims of Charlotte's bowl were significantly steeper than even a modern super speedway. (*Charlotte Observer.*)

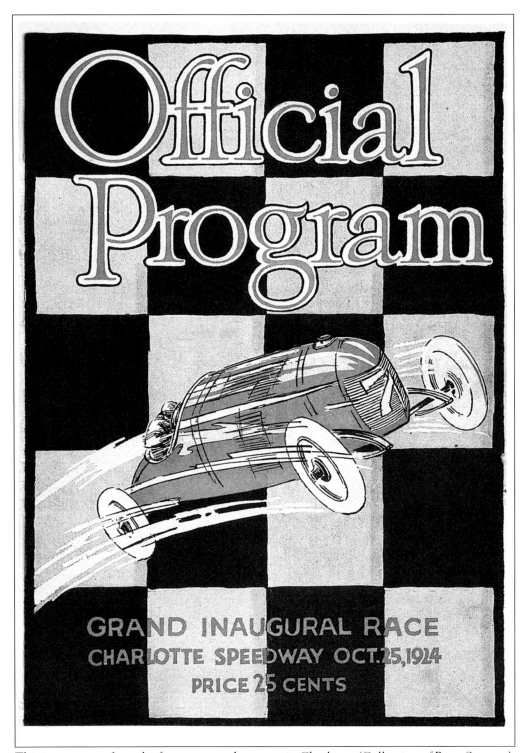

Official Program

GRAND INAUGURAL RACE
CHARLOTTE SPEEDWAY OCT. 25, 1924
PRICE 25 CENTS

This is a program from the first-ever speedway race in Charlotte. (Collection of Ryan Sumner.)

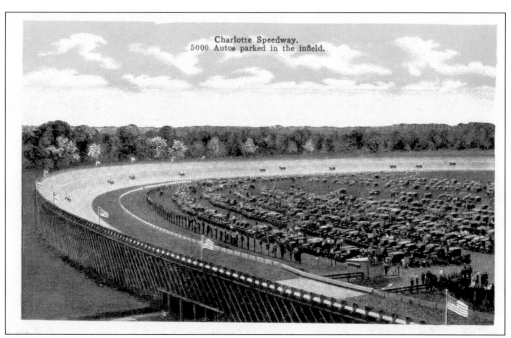

Charlotte Speedway.
5000 Autos parked in the infield.

From the beginning, fans have enjoyed watching the race from the infield. (Public Library of Charlotte and Mecklenburg County, Robinson-Spangler Carolina Room.)

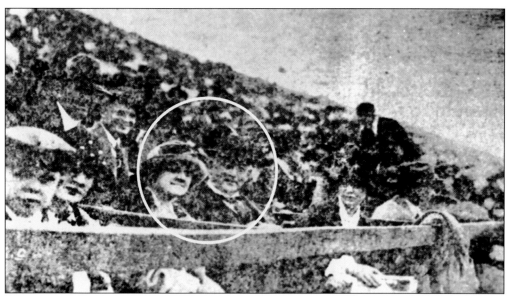

More than 50,000 spectators came to see the speed-demons in the inaugural event at the track, including some of Charlotte's biggest movers and shakers. Here, multi-millionaire industrialist James B. Duke and his wife are seen intensely taking in the spectacle. (*Charlotte Observer.*)

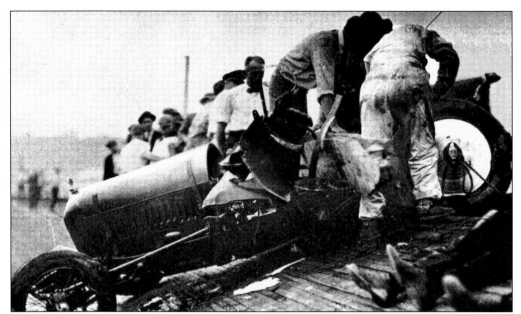

Auto racing was a dangerous endeavor, as this fatal wreck from the Altoona, Pennsylvania track shows. A similar accident in Charlotte took the life of driver Ernie Ansterberg, who crashed into the upper guardrail during the morning practice of the track's first race. Heart failure was given out as the cause of death, but mechanical investigation showed the accident was caused by a broken front suspension. It was the only death to cast its shadow on the Charlotte track. (Dick Wallen.)

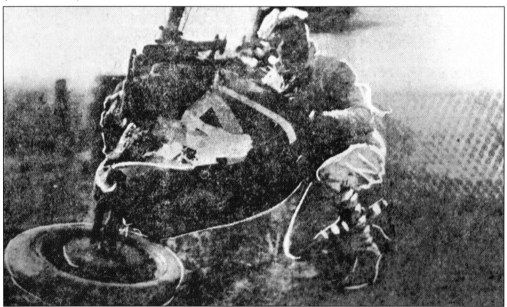

While racing in Charlotte on November 11, 1925, driver Bob McDonough—the young protégé of Tommy Milton—barely escaped serious injury after a tire blew on the 47th lap, causing him to crash into the railing. The impact spun the vehicle a few times, eventually flipping the open-cockpit car onto its back. "Whew, that was a close one," he said of the wreck. (*Charlotte Observer.*)

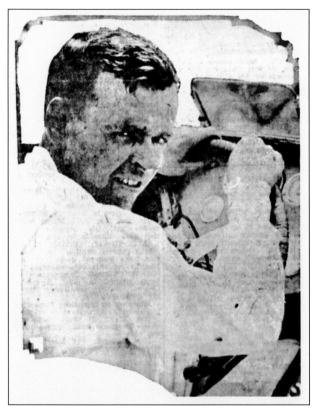

Tommy Milton, the son of a prosperous Minnesota dairy owner, was called the "speed king" during the 1920s and was the most popular driver who raced in Charlotte. The two-time Indianapolis winner took the checkered flag at the board track's October 1924 inaugural race, running the 250-mile event at an average speed of 118.17 mph—a world record. He drove to victory here again in November 1925. (above: *Charlotte Observer*; below, Ryan Sumner.)

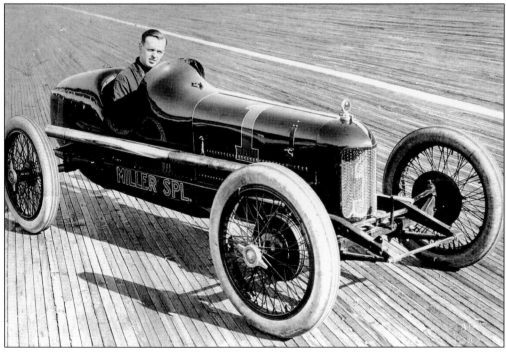

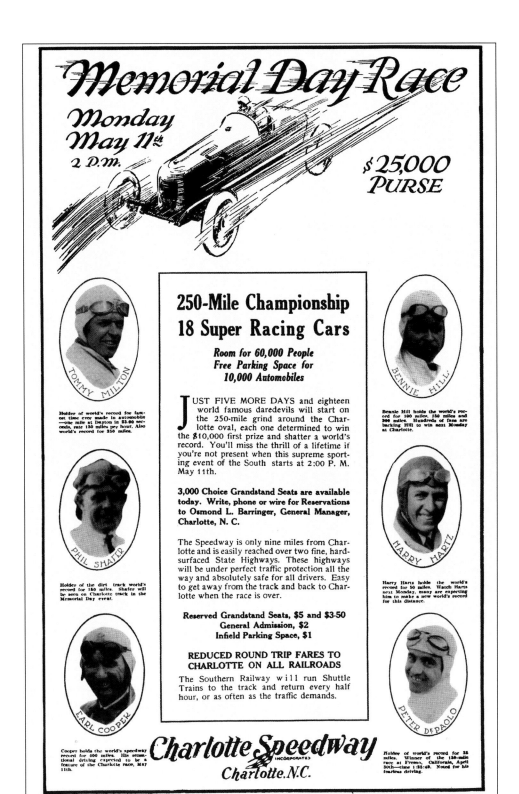

This advertisement appeared in the *Charlotte Observer* in May 1925. (*Charlotte Observer.*)

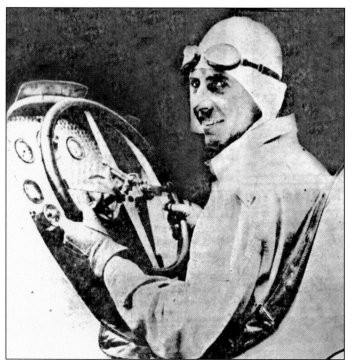

Harry Hartz, seen here in Charlotte, began his racing career in 1919 as the famous Eddie Hearn's ride-along mechanic. He would compete in Charlotte in eight races, winning an event on November 11, 1926 and placing second on four occasions. Hartz competed in 69 board track races throughout his career and was even crowned board track champion in 1926, but Harry was forgotten about largely because a win in the Indianapolis 500 eluded him. (*Charlotte Observer.*)

Here is Harry Hartz behind the wheel of a Miller-built racing car. Notice the insignia of the American Automobile Association, which began acting as a sanctioning body in the 1920s to end fixed races and impose solid rule structures on the sport. All the races at the Charlotte Speedway were run under AAA's watchful eyes. Today the Indy Racing League (IRL) and Championship Auto Racing Teams (CART) sanction this style of auto racing. (Collection of Ryan Sumner.)

This is an official program from November 11, 1925. (Collection of Ryan Sumner.)

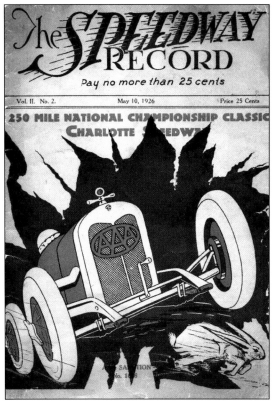

Pictured here is an official program from May 10, 1926. (Collection of Levine Museum of the New South.)

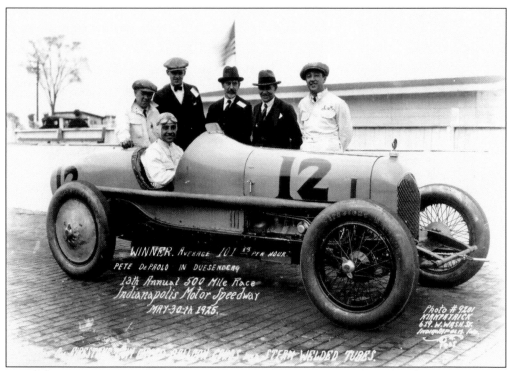

WINNER. Average 101 13 Per Hour.
PETE DePAOLO IN DUESENBERG
13th Annual 500 Mile Race
Indianapolis Motor Speedway
MAY 30th 1925.

Photo #9201
KIRKPATRICK
639. W. WASH.St.
Indianapolis Ind.

FIRESTONE GUM DIPPED BALLOON TIRES and STERN WELDED TUBES.

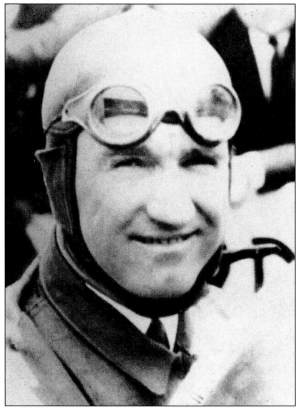

Driver Pete De Paolo won many Queen City hearts with his habit of tying one of his son's baby shoes inside his car. The Italian racing star found racing at the Charlotte Speedway—considered the fastest speedway in the world at the time—an exhilarating experience: "Going through those steep-banked turns, it looked as though you were going smack into a high board fence at 140 miles per hour." (Collection of Ryan Sumner.)

Earl Cooper was the winner of the Speedway's second race on May 11, 1925. (*Charlotte Observer*.)

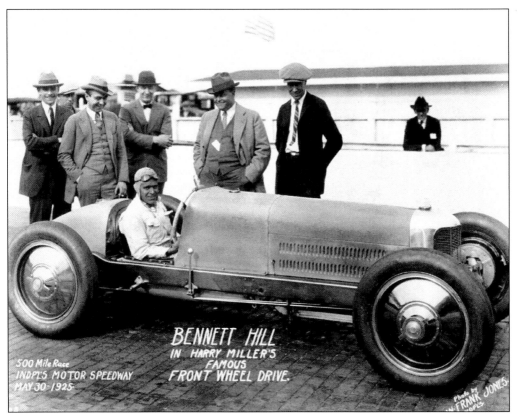

During tryouts prior to the October 1924 race, Bennett Hill became the first driver to break an established speed record for AAA racing at the Charlotte Speedway. (Collection of Ryan Sumner.)

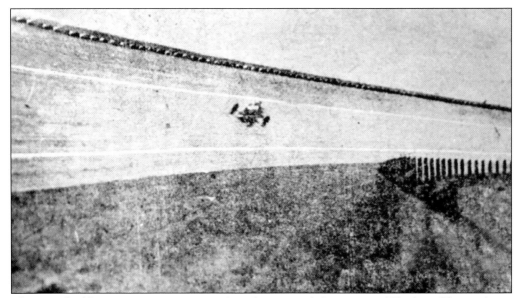

This is a plank's-eye view as racers come barreling toward the camera. (*Charlotte Observer.*)

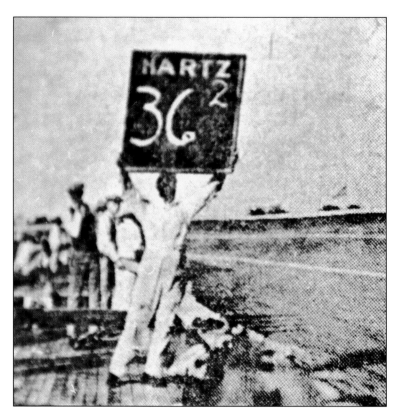

In the 1920s, pit crews communicated with their drivers by holding huge blackboards over their heads. Here a mechanic signals driver Harry Hartz that he has rounded the Charlotte oval in 36.2 seconds. Two-way radios would not find their way into race cars until 1952. (*Charlotte Observer.*)

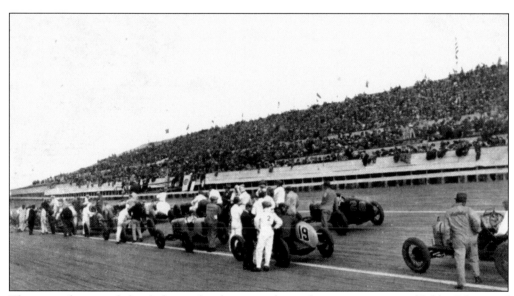

This view from track level shows the drivers and cars lining up to start. (Public Library of Charlotte and Mecklenburg County, Robinson-Spangler Carolina Room.)

This November 1925 advertisement asks readers to pick the winning driver in the upcoming race, but ironically, the eventual victor Tommy Milton is not pictured. (*Charlotte Observer.*)

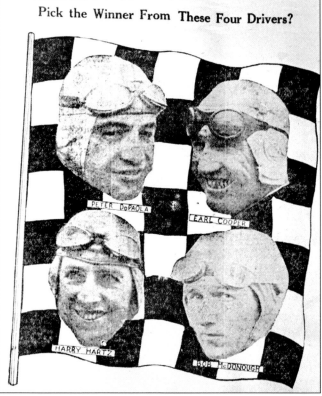

Pick the Winner From These Four Drivers?

PETER DePAOLA

EARL COOPER

HARRY HARTZ

BOB McDONOUGH

Leon Duray is apparently checking the condition of the boards at Charlotte. Duray was known for Hollywood good-looks and flair—he wore a black driving suit and called himself "The Black Devil" because he drove a race as though Lucifer himself was chasing him.

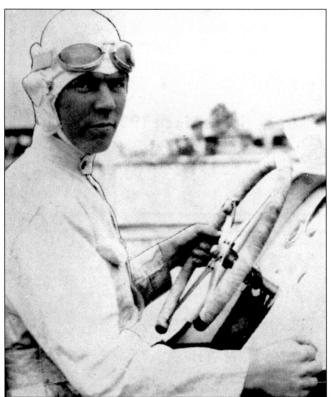

Frank Lockhart began his racing career on the west coast dirt tracks by driving home-built "junk-yard dogs" and was believed to be a true genius when it came to engine mechanics. Lockhart got involved in AAA racing in 1926 and won four of the nine races he entered in Charlotte, taking the checkered flag on every race where problems such as blown tires and broken super chargers did not prevent his finishing. (Collection of Ryan Sumner.)

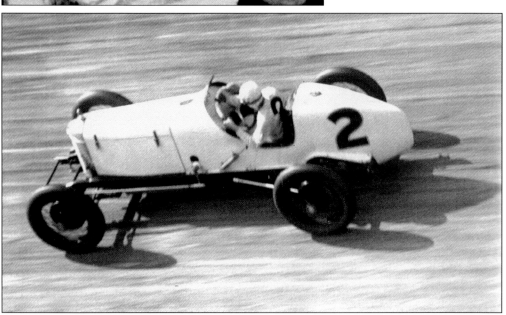

Frank Lockhart set the final record for the fastest lap at Charlotte on September 19, 1927 by reaching 138.89 mph. It no doubt looked like this picture of the speed-demon zooming around Culver City earlier that year. Frank died in April 1928 on the sands of Daytona Beach after an accident that followed his setting of a new land-speed record at 198.29 mph, which stood for 39 years.

Earl Devore began a 16-year racing career in 1912, running seven races in Charlotte and winning an important race on May 10, 1926. (Collection of Ryan Sumner.)

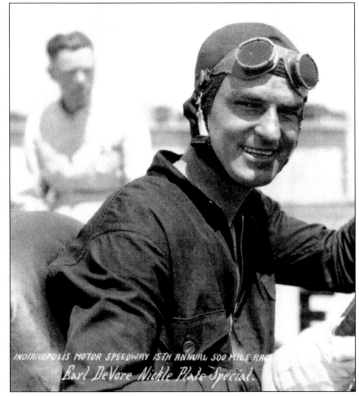

INDIANAPOLIS MOTOR SPEEDWAY 15TH ANNUAL 500 MILE RACE

Earl DeVore Nickle Plate Special.

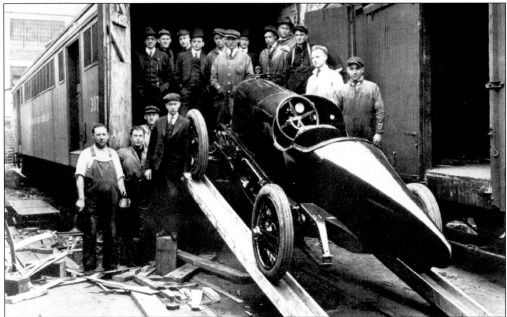

In the early days of auto racing, the cars would arrive by train much like the circus did. Charlotte Speedway was built adjacent to the rail line for this reason as well as to transport the spectators to the site. As with P.T. Barnum's spectacles, advance promotional men arrived well in advance of the event to stir up publicity for the race. (Collection of Dick Wallen.)

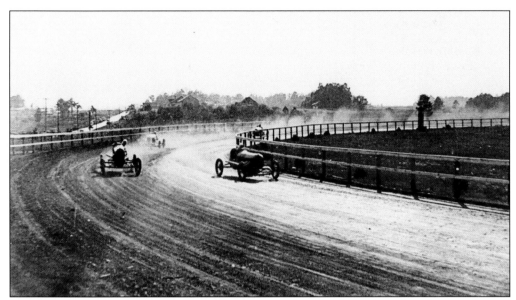

Weather and wear and tear took their toll on the pine boards of Charlotte Speedway, and major event racing, featuring nationally known drivers, faded away from this part of the South with the close of Osmond Barringer's race track in 1927. However, Southerners had acquired a taste for the sport and soon began to include auto racing at county fairs and small-town Fourth of July celebrations. Here we see such a race at the Salisbury Fairgrounds in 1937, run on an oval meant for horses. (*Salisbury Post.*)

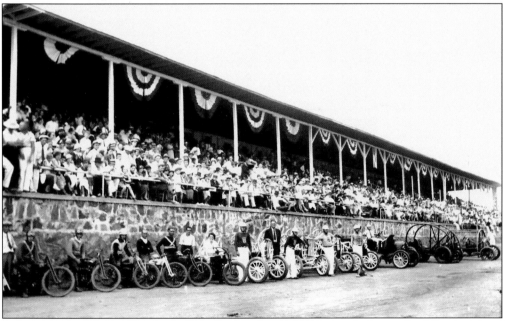

Motorcycle and automobile drivers and their mounts posed before kicking off a full schedule of races at the Cleveland County Fairgrounds in Shelby, 1930. The grandstand behind the drivers burned down in a Christmas Eve fire in 1951, but the track remains open. In recent years it has been the site of demolition derbies and mudslingers during the county fair. (North Carolina Office of Archives and History.)

Two

DIRT TRACK DEMONS

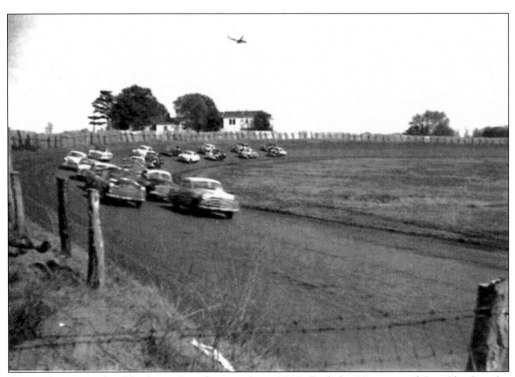

Racing began at the Charlotte Speedway in June 1948. Built by Harvey and Pat Charles, the track was the site of the very first NASCAR Winston Cup (then called "Strictly Stock") championship race on June 19, 1949. Located on the west side of town off Wilkinson Boulevard, the track hosted all kinds of racing before it closed in late 1956. (*Living Legends of Auto Racing.*)

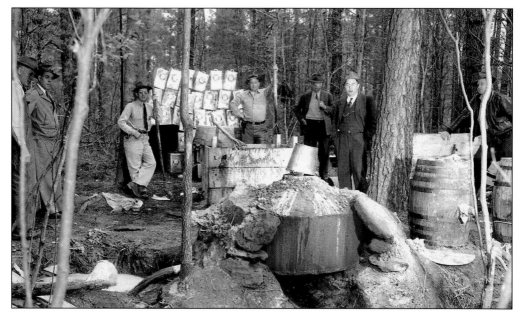

"Revenuers"—officials and enforcement agents—from the state Alcoholic Beverage Control Commission are seen here after raiding an illegal moonshine still in Barton's Creek Township in Wake County, 1946. After Prohibition ended, some North Carolinians distilled and sold their own spirits in remote rural areas. Since their success often depended on their ability to run their "white lightning" past the authorities, the moonshiners would modify their cars to make them run faster. When they began racing their cars against one another, modern stock car racing was born. In the early days of NASCAR, such notable drivers as Junior Johnson, Wendell Scott, and the Flock brothers used the experience they gained as moonshiners to achieve great success on the track. (North Carolina Office of Archives and History.)

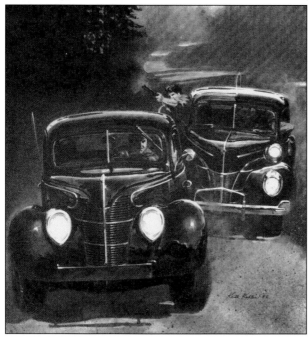

The excitement and romance of those early moonshining days have been captured by Keith Hohler's *Whiskey Trippin'*, which shows a "whiskey tripper," or illegal moonshiner, hotly pursued by revenue agents. (Auto Sports Gallery, Raleigh.)

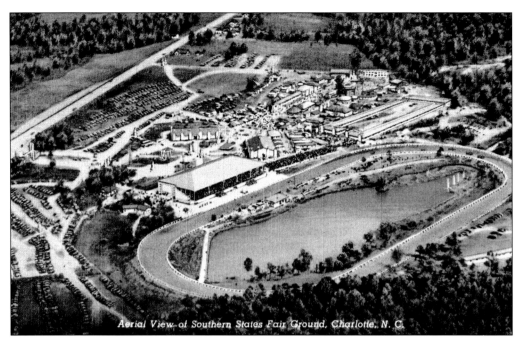
Aerial View of Southern States Fair Ground, Charlotte, N. C.

Charlotte's Southern States Fairgrounds, at the intersection of Sugar Creek Road and North Tryon Street, boasted a half-mile dirt track built in 1926. Auto racing there became a regular event beginning in 1937, but it became especially popular after World War II with the beginning of the "old time modified" circuit. These races featured pre-war cars, the only ones available as automakers began to return to production for civilians. By 1949, NASCAR had created its Strictly Stock Division, featuring new and late-model cars, and held regular events at the fairgrounds until Charlotte Motor Speedway opened in 1960. (Levine Museum of the New South.)

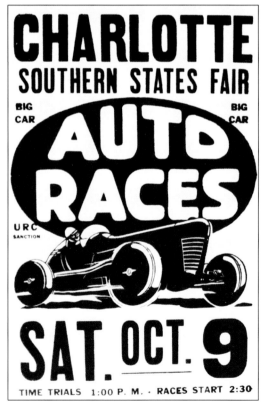

CHARLOTTE
SOUTHERN STATES FAIR

BIG CAR BIG CAR

AUTO RACES

URC SANCTION

SAT. OCT. 9

TIME TRIALS 1:00 P. M. · RACES START 2:30

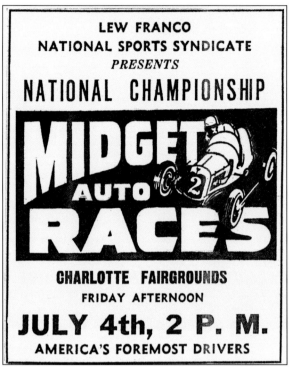

LEW FRANCO
NATIONAL SPORTS SYNDICATE
PRESENTS

NATIONAL CHAMPIONSHIP

MIDGET AUTO RACES

CHARLOTTE FAIRGROUNDS
FRIDAY AFTERNOON

JULY 4th, 2 P. M.
AMERICA'S FOREMOST DRIVERS

Midget auto racing was very popular across the United States in the years before and immediately following World War II. Crowds of 75,000 for midget racing were not unheard of in parts of the country. These miniature versions of the big Indy-style cars were more economical to operate, and spectators found them fun to watch. This midget auto race was held at the Charlotte Fairgrounds in 1947. (*Charlotte Observer.*)

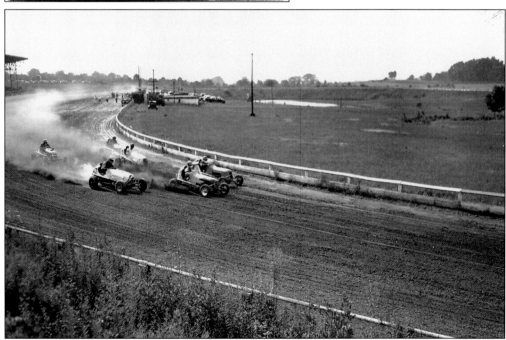

Midget racing was also popular at the North Carolina State Fairgrounds in Raleigh. The mile track at the fairgrounds was built in 1926 but converted into a half-mile bowl in 1940. Here we see a race between midget cars in 1947. The fairgrounds also occasionally hosted NASCAR Grand National racing and was the site of the last Grand National event on a dirt track, in 1970. (North Carolina Office of Archives and History.)

Buddy Shuman of Charlotte was another of the bootleggers who went on to a successful career in auto racing. He won dozens of races in modified cars in the years after World War II. In stock cars he was also a competitor, winning the 1948 Championship of the National Stock Car Racing Association, which briefly rivaled NASCAR in the post-war years. Tragically, Shuman died in a hotel fire in Hickory in 1955. NASCAR's lifetime achievement award is named in his honor. (International Motorsports Hall of Fame.)

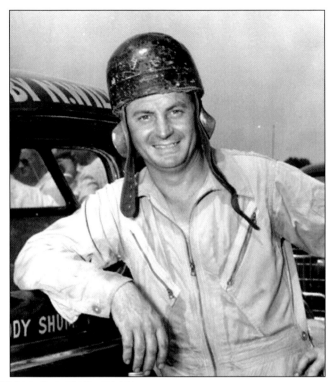

Tim Flock was one of the true pioneers of stock car racing. He was the NASCAR Grand National Series champion in 1952. In 1955, he won 18 races, the record until Richard Petty broke it in 1967. His 21.2 percent winning percentage (40 victories in 189 starts) is the best in NASCAR Winston Cup Series history. (Courtesy of Frances Flock.)

31

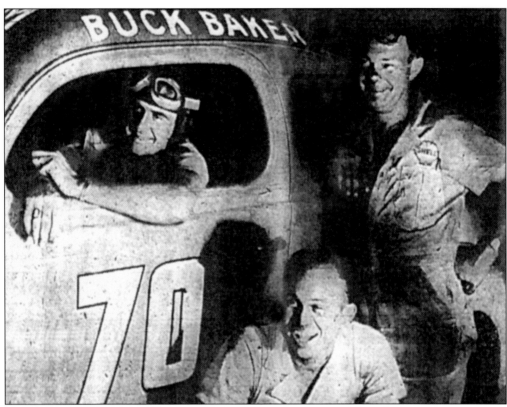

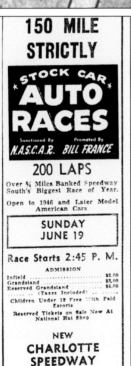

Buck Baker, one of the most successful stock car racers of the post-war era, is pictured here with mechanics Joe Rumph (middle) and Jimy Ross (right) prior to the inaugural race at Charlotte Speedway on Wilkinson Boulevard, July 11, 1948. In a career that spanned five decades, this former Charlotte city bus driver won nearly 50 Winston Cup races. "There was a time in the modified division that nobody could beat him," his son, Buddy Baker, once said. "He won 27 in a row once at the old Charlotte fairgrounds track, and the bad part was that we were the promoters at that track. They'd boo him coming in and boo him going out, but the next day everybody would be hanging around at his shop." (*Charlotte Observer.*)

This is an advertisement from the *Charlotte Observer* for the very first NASCAR-sanctioned Strictly Stock race, promoted by Bill France Sr. (*Charlotte Observer.*)

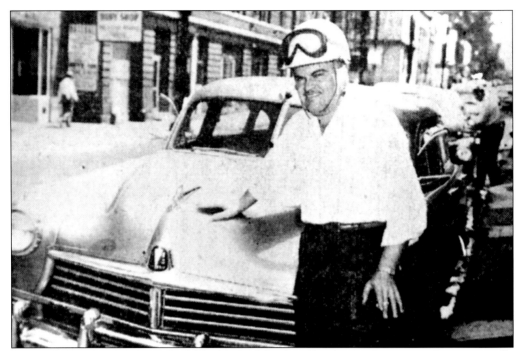

As a "whiskey tripper," Fonty Flock liked to find the sheriff and entice him into a chase, especially when Flock knew that his own modified car was faster. Fonty, who started racing before World War II, won races at every major track in the Piedmont, often while wearing Bermuda shorts. He and his racing brothers Bob and Tim dominated the early years of stock car racing, winning 63 Grand National races between them. Here he is in Charlotte with the 1949 Hudson that he would drive the following day in NASCAR's first "Strictly Stock" Race. (*Charlotte Observer.*)

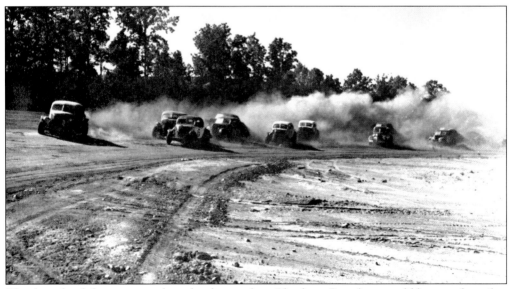

The dust cloud that was raised on the dirt track at Charlotte Speedway could be seen for miles. After attending a race at the Charlotte Speedway, journalist Furman Bisher wrote, "When I got home that night, even my underwear was red from all the dust." (NASCAR.)

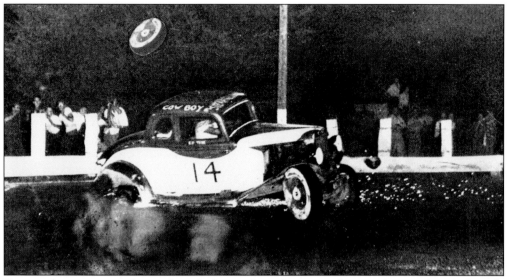

Dirt track racing was slower than Indianapolis-style racing, but as this unidentified, early modified wreck shows, it could easily be disastrous. (NASCAR.)

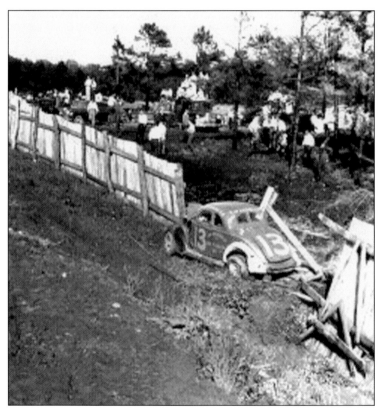

This is Lakeview, North Carolina, in 1948. Considering the ravine to the left of the car, the condition of the fence, and how far this car is from the spectators and their vehicles, it's a fair bet that this was one spectacular crash. (*Living Legends of Auto Racing.*)

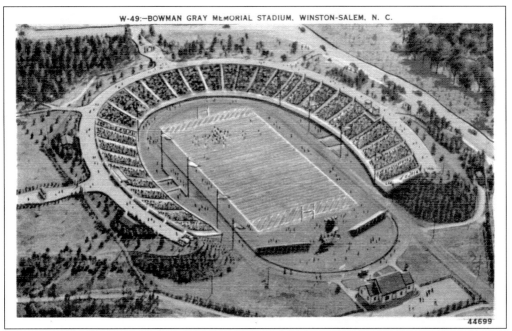

Since 1947, Bowman-Gray Stadium in Winston-Salem has hosted auto racing. This unusual quarter-mile paved oval track actually runs around the inside of the stadium where Winston-Salem State University plays football games and other athletic events. Grand National events ran at Bowman-Gray until 1971, but NASCAR still sponsors its Weekly Racing Series at the track. The image above shows a postcard from the late 1940s, and the photograph below is a modified race from the same period.

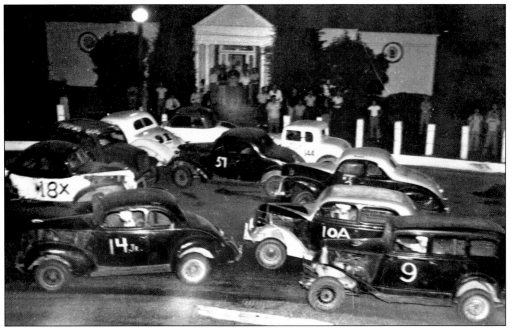

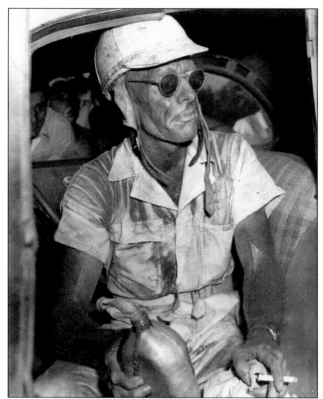

Robert "Red" Byron was shot down during World War II while serving as a tail gunner on a B-24. He spent 27 months in the hospital while doctors tried to repair his severely injured left leg. Determined to race as he had before the war, Red had his leg bolted to the clutch in his first race back in 1946, which he won. Red Byron went on to win the very first NASCAR race in 1948 and was NASCAR's first champion in 1949. (International Motorsports Hall of Fame.)

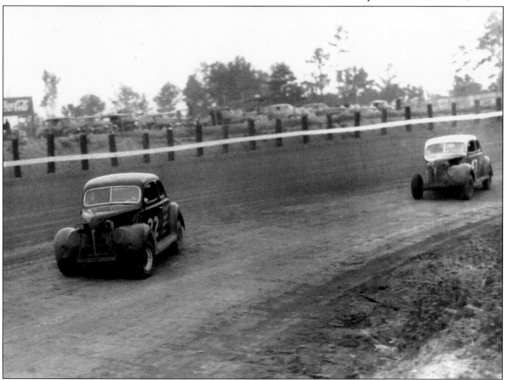

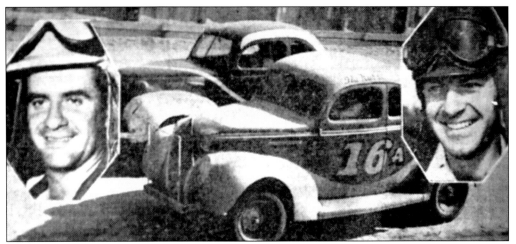

Buck Baker (left) and Curtis Turner (right) were two of the most popular drivers in the Charlotte area. Each of them drove in dozens of races around the Piedmont before committing to the NASCAR Grand National circuit. Though the local press tried to create a rivalry between Baker and Turner, the two men got along well. (*Charlotte Observer.*)

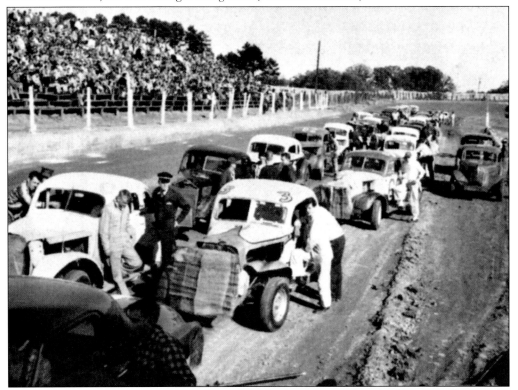

This photograph shows modified cars lining up prior to a race at the Charlotte Speedway in the early 1950s. In contrast to the strict safety measures of today's vehicles, modifieds in NASCAR's early days sported whatever equipment their drivers and mechanics felt like installing. Because of the extra weight, many drivers didn't even use roll cages, which are a basic component today. Each car reflected the skills, preferences, and financial resources of the team, which meant that no two cars were alike. (Photographer unknown.)

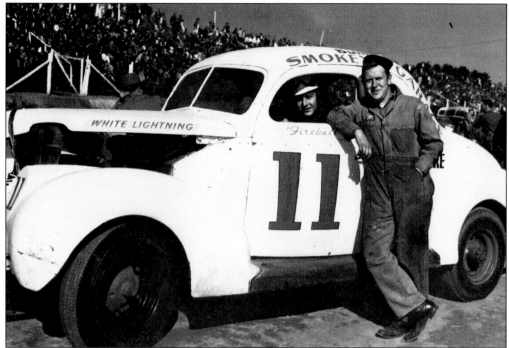

Glen "Fireball" Roberts sits inside his car, "White Lightning," at the dirt Charlotte Speedway off Wilkinson Boulevard. Roberts, who is considered the first superstar of modern stock car racing, won 32 Grand National races before an untimely death resulting from a crash in the 1964 World 600 in Charlotte. (Photographer unknown.)

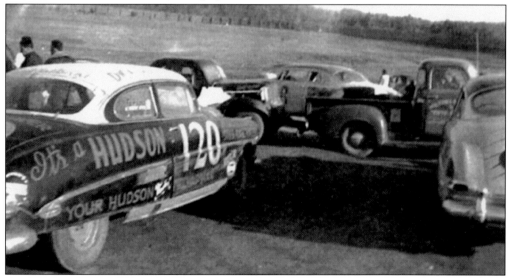

Fans' cars and race cars would all meet up in the parking lot at the old Charlotte Speedway. Most prominent in the foreground of this shot is the new, but already race-tested, 1953 Hudson. From 1951 to 1954, Hudson automobiles dominated the racing circuit. Herb Thomas, Tim Flock, and others drove Hudsons to victory in 27 out of 34 NASCAR events in 1952. Hudson Motors merged with Nash in 1954 to form American Motors, which had an undistinguished racing career, winning only one event in Charlotte, in 1978. (*Living Legends of Auto Racing.*)

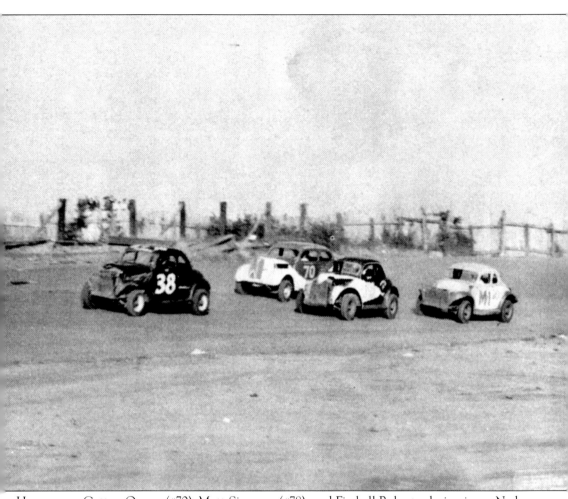

Here we see Cotton Owens (#70), Mutt Simpson (#78), and Fireball Roberts closing in on Ned Jarrett (#38) at Charlotte. (Photographer unknown.)

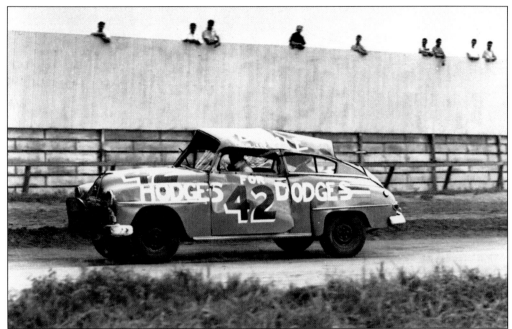

Pictured is Lee Petty of Level Cross, North Carolina in his 1952 Dodge at the end of a particularly grueling race. Beginning with the first Grand National race in 1949, there has been a Petty in every NASCAR event held in Charlotte for over 50 years. Lee Petty was a fierce competitor: in 1958 he rammed a car he was trying to pass, sending it into the wall—the other car was driven by his son Richard, starting in his very first Grand National race. In 16 years of professional racing, Lee Petty won 55 events and the Grand National championship three times. From 1949 to 1959, he never finished lower than fourth in the final rankings. Lee was voted most popular driver in NASCAR twice and was even voted mechanic of the year in 1950. (Above: unknown photographer; below: History Room, Charles A. Cannon Memorial Library, Kannapolis Branch.)

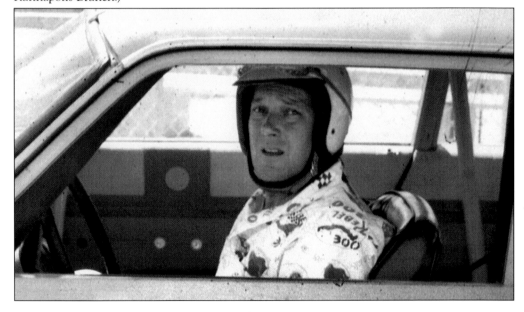

Ned Jarrett once called Ralph Earnhardt, of Kannapolis, North Carolina, "absolutely the toughest race driver I ever had to race against." Though Ralph occasionally did race in NASCAR's Grand National Series, he preferred to stay closer to home to be with his family. He was best known for his success on such short tracks in the Carolinas such as Hickory, Greenville-Pickens, Metrolina, and Concord. A master mechanic and innovator, Ralph was the first to install crash bars in his cars to protect the driver. (ISC Publications Archives.)

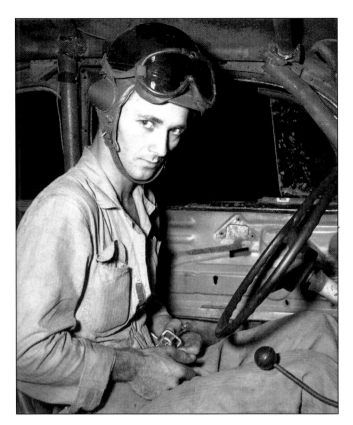

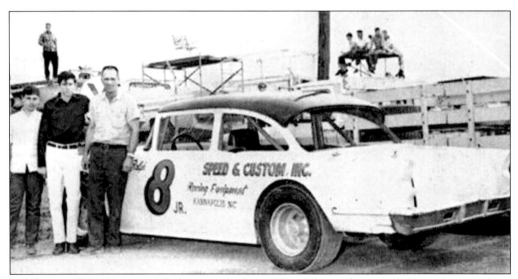

Ralph was still building modified cars in the late 1960s and into the early 1970s and racing them at local tracks. Here he is in front of his 1955 Chevrolet at Concord Speedway with his two oldest sons, Dale and Randy, who were part of his pit crew. He died suddenly on September 26, 1973 while working on a race car in his shop. (Bob Coleman.)

Herb Thomas, a former truck driver from Barbecue Township, North Carolina, was one of the early stars of the NASCAR circuit, winning the championship in 1951 and again in 1953, when he chalked up an impressive 12 victories. His career suffered a serious setback in October 1956, shortly after this photograph was taken, when he was injured in a crash at the Shelby County (NC) Fairgrounds, which left him partially paralyzed. He overcame nearly insurmountable obstacles to race the following year, but he was unable to regain his early success. (North Carolina Office of Archives and History.)

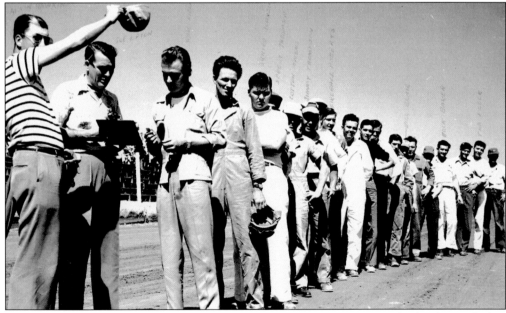

NASCAR officials Alvin Hawkins and Joe Epton check things over with the drivers before a race at the old Greensboro Agricultural Fairgrounds in 1957. Hawkins was NASCAR's first flagman; he later co-owned a car with Bill France and promoted races at Bowman-Gray Stadium and other Carolina venues. Epton was NASCAR's chief timer and scorer for over 40 years. Among the drivers above are Junior Johnson, Buck Baker, Tim Flock, Speedy Thompson, Cotton Owens, and Fireball Roberts. (North Carolina Office of Archives and History.)

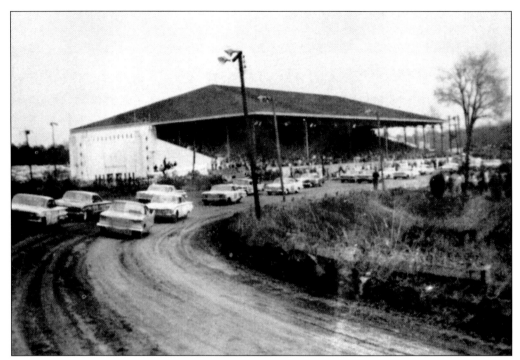

This 1960 photograph shows the beginning of the last race ever held at the Charlotte Fairgrounds. Lee Petty and Buck Baker are leading the field, waiting for the green flag to drop.

Cotton Owens of Spartanburg, South Carolina won more than 100 NASCAR Featherlite Modified Tour races during the 1950s (mostly on dirt tracks) before moving on to the NASCAR Grand National Series competition. Motivated to excel in front of a hometown crowd, Owens claimed three wins in 1960, all of them in his home state of South Carolina. His most successful season was in 1959 when he won two races, notched 22 top-10 finishes (through 37 starts), and ranked second behind Lee Petty in the series's season-long points chase. (*Charlotte Observer*, photograph by Don Hunter.)

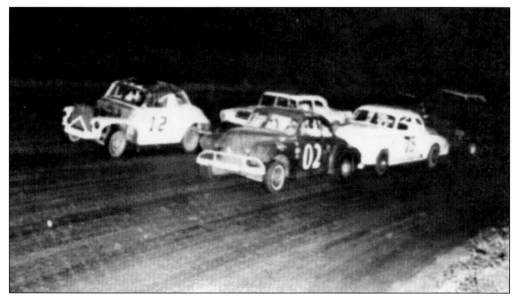

From 1955 until 1979, Concord Speedway was an active dirt track that was home to many stars of that era and today. Concord was a half-mile high banked clay dirt track. It was home to weekly stock car racing, some Grand National races in the late 1950s and early 1960s, and an occasional motorcycle race. Curtis Turner, Ralph Earnhardt, and Speedy Thompson all raced at Concord Motor Speedway, and Dale Earnhardt began his racing career there. The Speedway closed when the land was sold for a housing development. (Bob Coleman.)

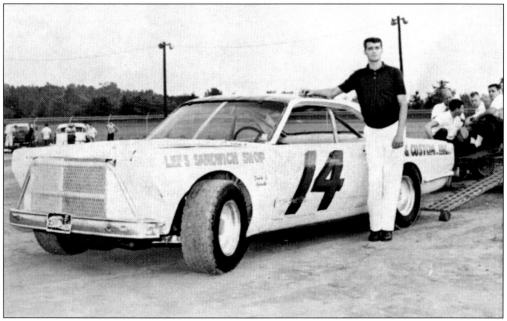

Heywood Plyler is pictured above with his Ford Fairlane at Concord Speedway in the early 1960s. Heywood raced around the Piedmont area of North Carolina for his entire career. Moving up from the "Semi-Modified" ranks to the Sportsman ranks, he became a leading dirt track driver. Legend has it that Ralph Earnhardt helped teach him how to drive on dirt at the Towel City Speedway. (Bob Coleman.)

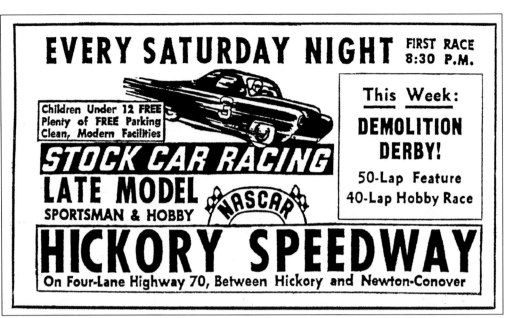

Hickory's dirt track opened in 1951 and is the oldest continually operating motor speedway in the country. Known as "The World's Most Famous Short-Track" and "The Birthplace of The NASCAR Stars," the track, which was paved in 1967, still plays host to weekly events. (*Charlotte Observer.*)

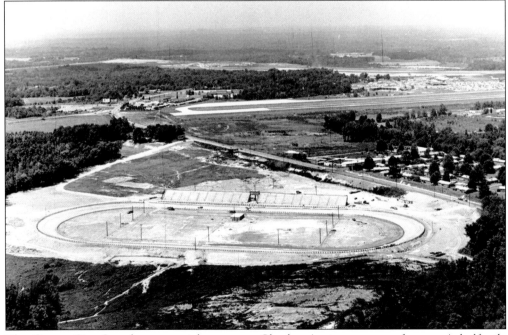

The Queen City Speedway was right next to Charlotte's airport west of town. A half-mile clay track, Queen City was built in the late 1960s and only survived a year or two. Despite its location next to Charlotte-Douglas Airport, the track faced opposition from homeowners who complained about the noise. Perhaps Charlotte couldn't support three professional tracks at once, for Queen City ceased operation in 1968. (*Charlotte Observer*, Elmer Horton.)

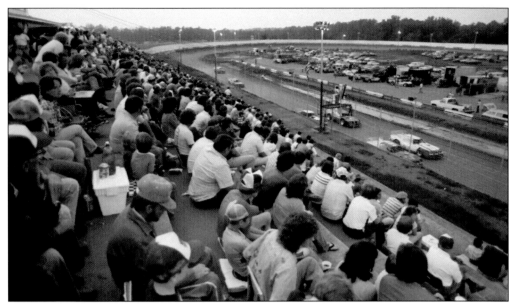

Built in the mid-1960s and located at the Metrolina Fairgrounds in northeast Charlotte, Metrolina Speedway went through several transformations. The usually half-mile banked clay track, which operated as Speedworld for a time, was paved briefly in the 1970s and ran NASCAR-sanctioned races promoted by Ned Jarrett. Dale Earnhardt won his first asphalt race there. Metrolina also ran "Run Whatcha Brung" races where anything was legal—nitrous oxide, spoilers, and all manner of modifications were common. Unfortunately, even with drivers such as Jack Ingram, Harry Gant, Butch Lindley, and Dale Earnhardt competing there, Metrolina was never a huge financial success for its operators. The track ran off and on until finally closing for good in 1998. (Robinson-Spangler Carolina Room, Public Library of Charlotte and Mecklenburg County.)

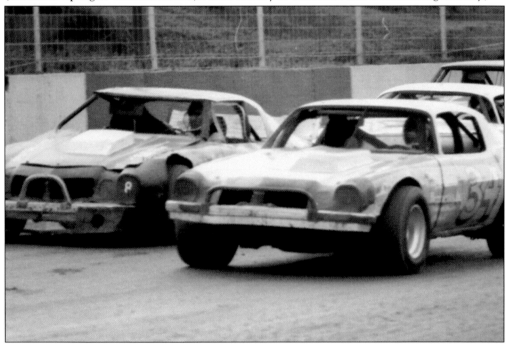

Carolina Speedway opened in Gastonia in 1962 and has been running a variety of racing events on its 4/10-mile clay oval track ever since. Carolina Speedway is typical of the many smaller tracks in the Carolina Piedmont area: its core racing fans come back every week to follow their favorites and cheer on competitors, who are regulars too. (*Charlotte Observer.*)

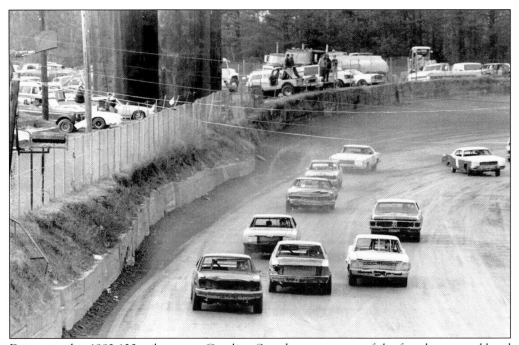

Drivers in this 1992 100-mile race at Carolina Speedway come out of the fourth turn and head down the straight-away.

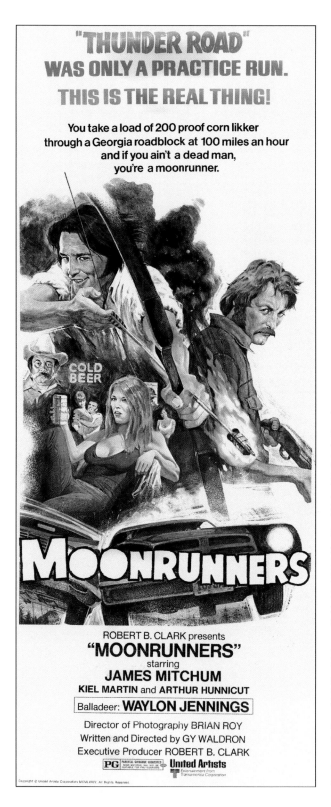

"THUNDER ROAD"
WAS ONLY A PRACTICE RUN.
THIS IS THE REAL THING!

You take a load of 200 proof corn likker
through a Georgia roadblock at 100 miles an hour
and if you ain't a dead man,
you're a moonrunner.

COLD
BEER

MOONRUNNERS

ROBERT B. CLARK presents
"MOONRUNNERS"
starring
JAMES MITCHUM
KIEL MARTIN and ARTHUR HUNNICUT
Balladeer: WAYLON JENNINGS

Director of Photography BRIAN ROY
Written and Directed by GY WALDRON
Executive Producer ROBERT B. CLARK

PG PARENTAL GUIDANCE SUGGESTED
SOME MATERIAL MAY NOT BE
SUITABLE FOR PRE-TEENAGERS

United Artists
Entertainment from
Transamerica Corporation

Copyright © United Artists Corporation MCMLXXIV. All Rights Reserved.

The 1975 film *Moonrunners* and the subsequent 1979–1985 television series it inspired, *The Dukes of Hazzard*, have their roots in the Carolina Piedmont. Jerry and Johnny Rushing ran moonshine for their Uncle Worley near Monroe, North Carolina in the 1950s. Their female cousin Delane would often hang around with the boys, who had numerous adventures and near escapes running liquor and racing on Carolina dirt tracks. On drive-in movie screens of the 1970s, car chase films were very popular and director Gy Waldron turned his friend Jerry Rushing's stories into the movie, giving him credit as a technical advisor. Warner Brothers turned the cornpone comedy into the *Dukes* television series, cleaning things up a bit and moving the setting to a mythical county in Georgia. (Collection of Ryan Sumner.)

Three

THE SUPERSPEEDWAY ERA

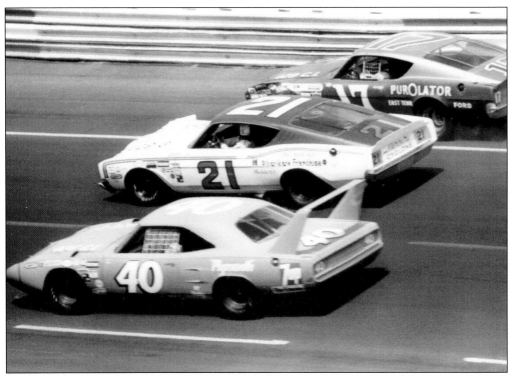

Stock car racing was born on dirt raceways carved from Carolina clay, but the sport came of age on the South's paved super-speedways. Charlotte Motor Speedway, Darlington Raceway, North Carolina Motor Speedway in Rockingham, and Southland in Raleigh were all located in the Carolina Piedmont. Along with Daytona, this is where modern Winston Cup Grand National racing matured into the second most-popular sport in America. (Robinson-Spangler Carolina Room, Public Library of Charlotte and Mecklenburg County.)

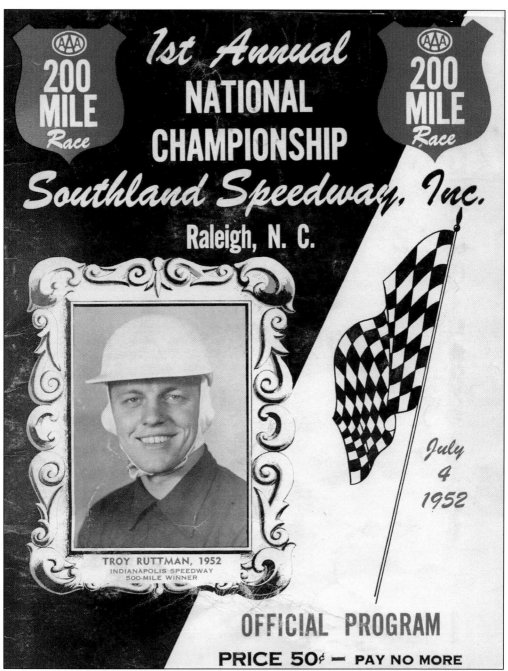

Southland Speedway, erected in 1952, was North Carolina's first modern speedway built with high banks and a paved racing surface. The opening battle at the new Raleigh bowl was a AAA-sanctioned Indy-car race, but NASCAR Grand National racing took over the following year. Southland (also known as the Raleigh Speedway and Dixieland Speedway) was the first to erect lights for night racing in 1955. The track only lasted seven years and closed in 1959, when its Fourth of July event was moved to Daytona. (Collection of Ryan Sumner.)

50

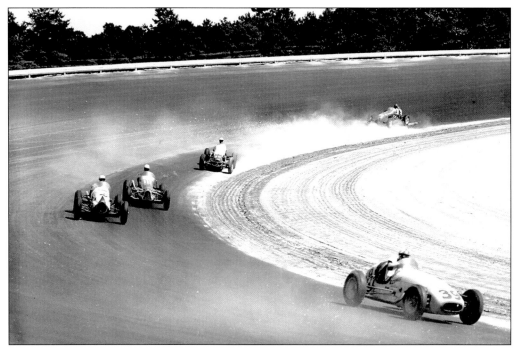

Open-wheel Indy cars race around the just-finished Southland Speedway in 1952. The track was paved, but the cars are stirring up dust from the lower apron where grass had yet to grow. (North Carolina Office of Archives and History.)

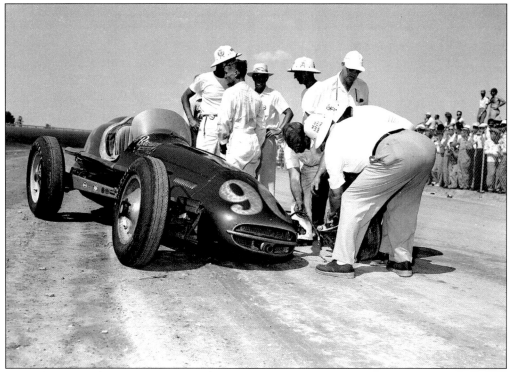

Officials surround Joe James's mount after it lost a wheel during the race.

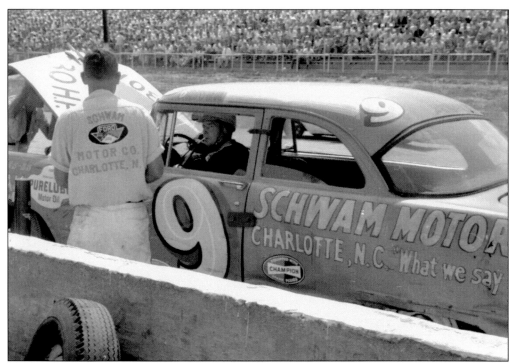

Billy Carden, driving for Curtis Turner, pulls the Schwam Motor Company Ford out of the pits during the Fourth of July 1956 Grand National race at Raleigh Speedway. (North Carolina Office of Archives and History.)

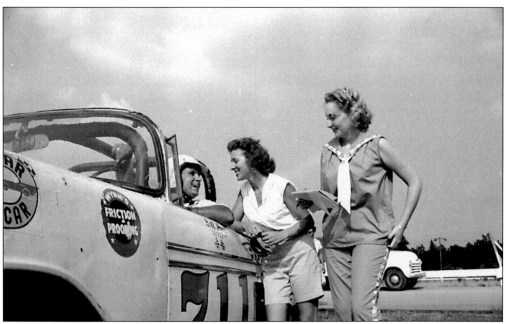

Driver Bill Poor flirts with a pair of female fans prior to the 1958 Raleigh 250, a race that featured both hard-top cars and convertibles. The convertible series was popular with fans because they could see the driver piloting the car. (North Carolina Office of Archives and History.)

As NASCAR racing became centered on super-speedways, it garnered greater attention from sponsors seeking national exposure. In the 1950s and 1960s, advertisers tended to be related to the automotive industry, as illustrated by this battery additive endorsed by Lee Petty. When the FCC banned cigarette companies from advertising on television in 1970, tobacco firms sank their money into racing. The logos of beer companies and other groups seeking to reach "male demographics" emblazoned cars of the 1970s and 1980s. (Collection of Ryan Sumner.)

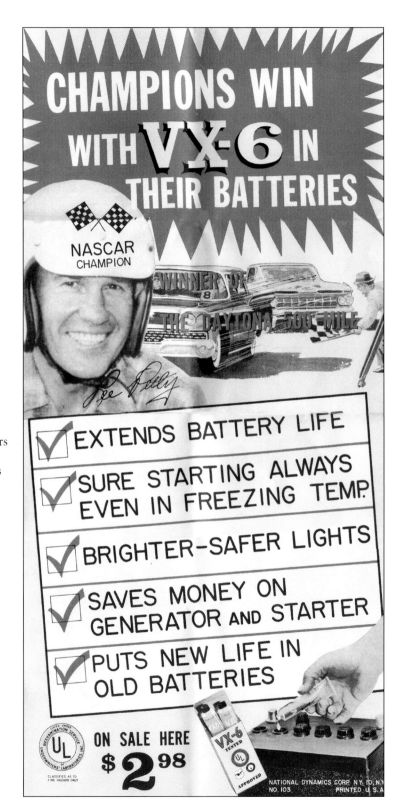

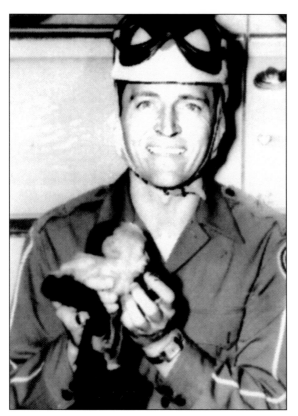

Although Tim Flock boasts one of the most impressive records in the sport, including the highest win percentage of any driver, he is best known for his simian side-kick, a rhesus monkey named Jocko Flocko who rode with Flock during 1953. Jocko even had his own driving suit and goggles! In a race at Raleigh, Jocko got out of his safety harness and pulled open a trap door in the floorboard of the car. When he stuck his head through, he was hit by a rock or zipped by the tire. The monkey went crazy and Tim had to pull into pit to remove the frightened animal. (Courtesy of Frances Flock.)

Recently, the exploits of Tim Flock and Flocko Jocko provided inspiration to artist Matt Kindt, who featured them in a 2002 SPX comics anthology.(Copyright Matt Kindt, 2003. Used with permission.)

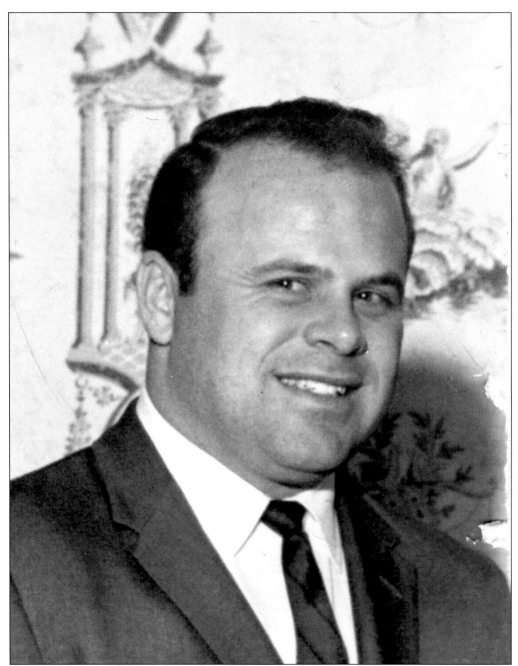

O. Bruton Smith was a former car dealer and dirt-track promoter who organized races in Shelby and other places in the 1950s. Smith wanted to build a large two-mile super-speedway in Charlotte near the site of the original Charlotte Speedway in Pineville. At the same time, racing legend Curtis Turner announced plans of his own to build a major race track on Highway 49 just north of Charlotte. Though Turner initially expressed reluctance—saying in 1959 that "regardless of what he does, we plan to go ahead with our plans. If he builds, too, it looks as if Charlotte will have two tracks"—Turner decided to combine efforts with Smith and build the Charlotte Motor Speedway. (*Charlotte Observer.*)

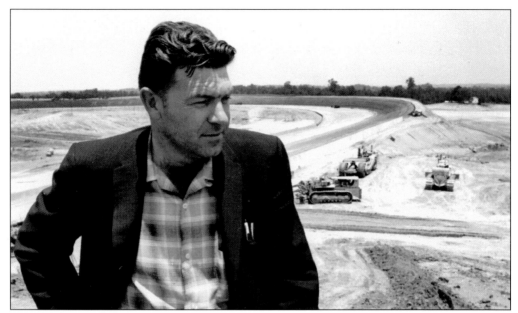

Curtis Turner watches the construction of the Charlotte Motor Speedway north of Charlotte in Cabarrus County. (Robinson-Spangler Carolina Room, Public Library of Charlotte and Mecklenburg County.)

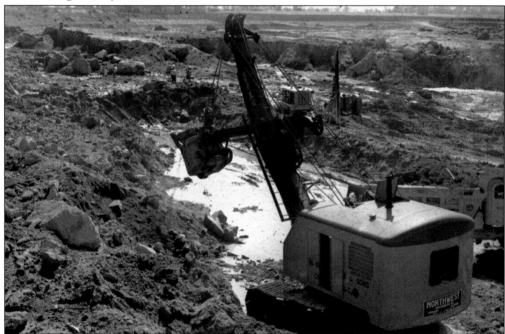

Numerous problems plagued the construction of the Charlotte Motor Speedway. W. Owen Flowe & Sons was contracted to remove the dirt and rock from the construction area, but they soon encountered a major obstacle: half a million yards of solid granite under the building site, which the core drill report had failed to reveal. The only way to remove the granite was to dynamite it, an expensive solution that pushed costs more than a half a million dollars over budget. (History Room, Charles A. Cannon Memorial Library, Kannapolis Branch.)

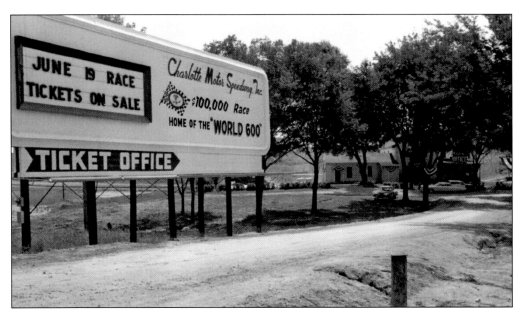

The inaugural "World 600" at the Speedway was originally set for May 29, 1960, but construction delays necessitated moving the event to June 19th. The $100,000 purse marked the first time NASCAR prize money reached into six figures. Behind the sign located on Highway 49, it is just possible to make out the original ticket office, located in the historic 1774 home of the state's first elected governor, Nathaniel Alexander. The building survived on the site until the 1970s. (Public Library of Charlotte and Mecklenburg County, Robinson-Spangler Carolina Room.)

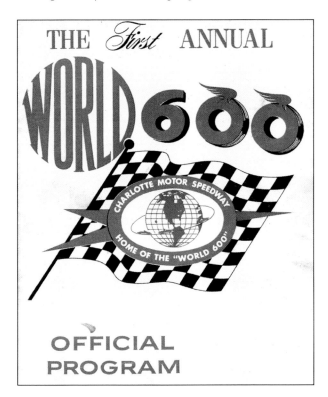

For Piedmont residents who were used to dirt-track events, where speeds rarely topped 50 mph, it must have been incredible to watch drivers battle at speeds well in excess of 100 mph. Joe Lee Johnson emerged victorious in the first World 600, which was fraught with problems such as broken asphalt and dust storms from the un-landscaped infield. (Levine Museum of the New South.)

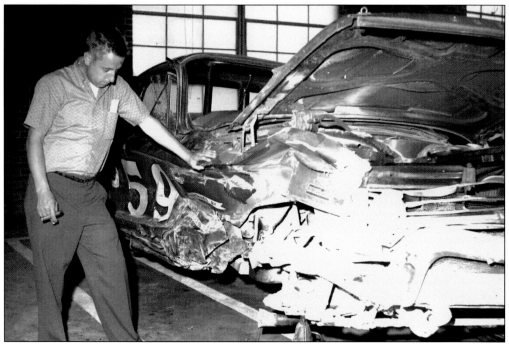

During tire testing for the October 1960 National 400, the second race held on the new speedway, Tom "Tiger" Pistone of Chicago blew a tire which sent him crashing into the track's first turn. He escaped injury, which is amazing given the state of his car. (History Room, Charles A. Cannon Memorial Library, Kannapolis Branch.)

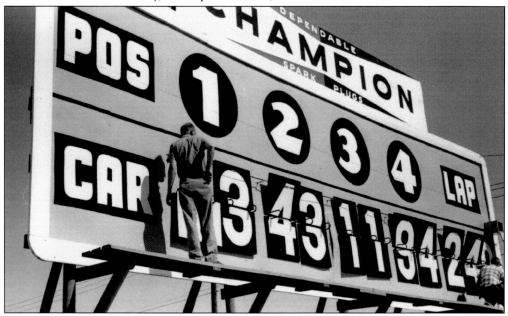

The original scoring pylon, or leader board, at Charlotte Motor Speedway let spectators know how their favorite drivers were doing. Unfortunately, the large tiles had to be changed by hand, which was no doubt much more exhausting for these men than for their baseball counterparts. (Robinson-Spangler Carolina Room, Public Library of Charlotte and Mecklenburg County.)

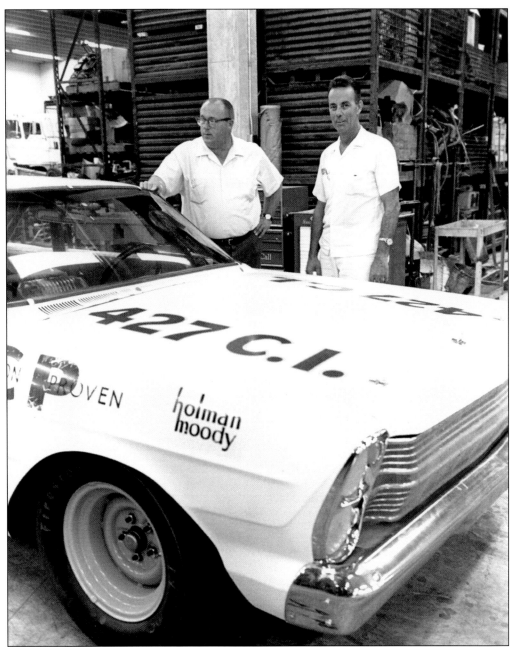

Ford's enormous racing success in the mid-1950s through the early 1970s was due to the Charlotte-based partnership of John Holman and Ralph Moody. Beginning in 1956, they headed up Ford's directly-subsidized stock-car racing team, winning 80% of the NASCAR Grand National, Convertible, and Short Track races in 1957. Later that year, factory teams were banned, so they bought all of Ford's parts and equipment and continued what they started, fielding cars driven by Curtis Turner, Joe Weatherly, Fred Lorenzen, and Fireball Roberts, to name a few. (Courtesy of Lee Holman, Holman-Moody, Inc.)

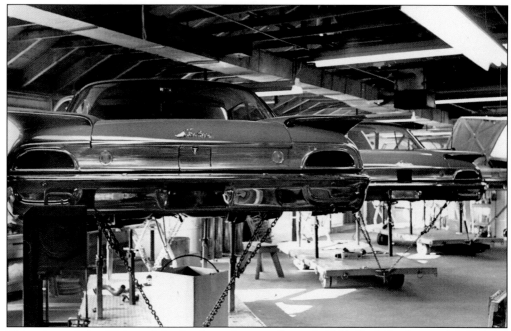

This view of the Holman-Moody shop shows a fleet of 1960 Ford Starliners about to be transformed into race cars by the dozen-or-so top mechanics employed by the team. They would reinforce the chassis, install roll cages, precision tune the engines, and give them aluminum manifolds and high compression heads. They would also add high performance equipment such as Holman-Moody-built wheels, spindles, stabilizers, camshafts, and full floating rear axle housings. (*Charlotte Observer.*)

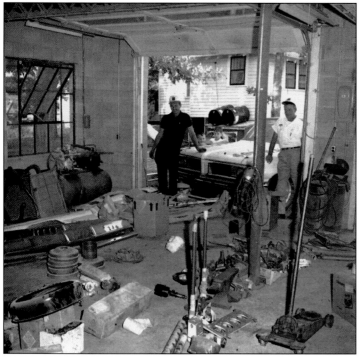

Most NASCAR competitors worked out of race shops more humble than Holman-Moody's operation. This 1962 photograph from the Concord-Kannapolis area shows the more common arrangement— a shop converted from a back-yard garage. Family was always nearby and often turned wrenches and worked on pit-crews. (History Room, Charles A. Cannon Memorial Library, Kannapolis Branch.)

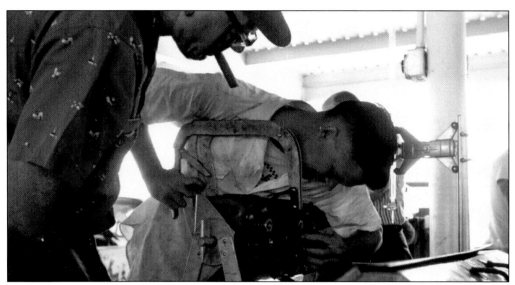

Under the watchful eye of a NASCAR technical inspector, a race team mechanic uses a valve spring clamp to work on a cylinder head prior to a race in Charlotte in 1960. NASCAR has very strict rules to prevent cheating. Over the years enterprising mechanics have used oversized gas tanks and fuel lines; big engines and carburetors; components fashioned from lead to add weight or titanium to reduce it; tires soaked in chemicals to improve adhesion; illegal clutches, flywheels, camshafts, and rollers; bogus body work; retractable fenders and spoilers; cheater carburetors; and even nitrous oxide. (Robinson-Spangler Carolina Room, Public Library of Charlotte and Mecklenburg County.)

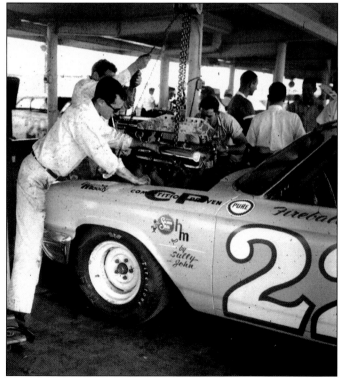

Every race fan knows the names of the NASCAR drivers. But if not for the countless hours that team mechanics labor, the cars would not run. They receive no fame, no glory, no endorsement contracts. The most they can expect is a paycheck, a pat on the back, and an occasional ride to victory lane. But not everyone participates in racing for the glory or the fame—they just want to be a part of the sport. Here, mechanics lower the engine into Fireball Roberts's car trackside. (History Room, Charles A. Cannon Memorial Library, Kannapolis Branch.)

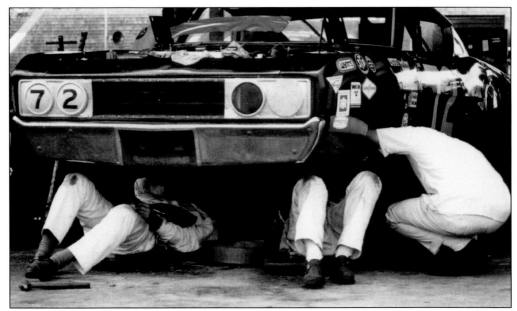

Weeks of mechanical preparation can go into getting a stock car ready to race. This work continues almost up until the moment the green flag drops. Here Benny Parsons's crew makes last-minute adjustments before an October 1970 race at the Charlotte Motor Speedway. (Robinson-Spangler Carolina Room, Public Library of Charlotte and Mecklenburg County.)

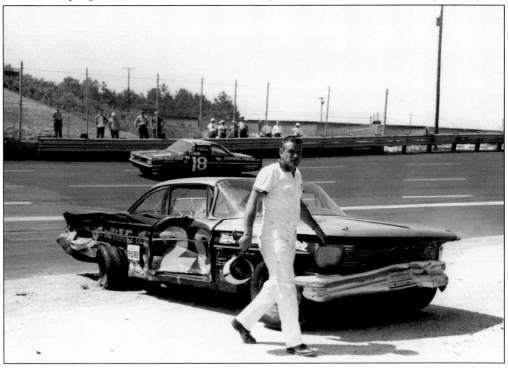

Marvin Panch stews angrily outside his wrecked 1960 Pontiac. He blew a tire in the fourth turn of lap 135 and was hit by Larry Frank, who was driving relief for Curtis Turner. (Robinson-Spangler Carolina Room, Public Library of Charlotte and Mecklenburg County.)

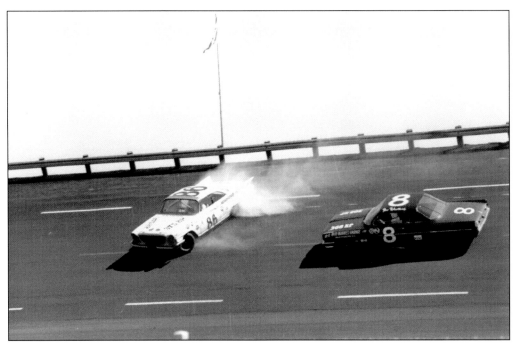

Unable to swerve, Joe Weatherly (No. 8) bores in on Buddy Baker, sending Baker's car spinning in May 1961. (Robinson-Spangler Carolina Room, Public Library of Charlotte and Mecklenburg County.)

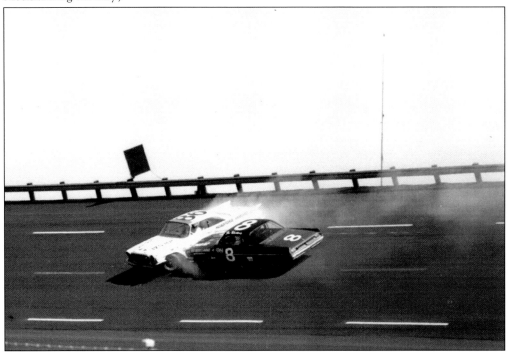

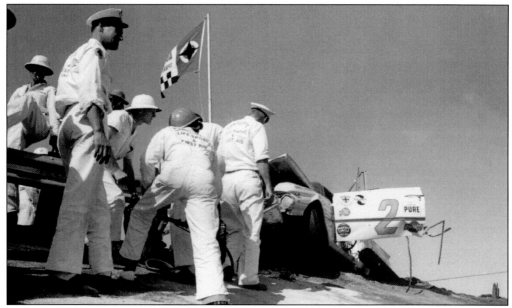

While negotiating Turn Four's 24-degree banks on the 287th lap of the second World 600, 8-year racing veteran Reds Kagle blew a tire, sending his mount into the upper guard rail. After the initial impact, the car careened end over end, paused slightly with its tail pointing skyward and then flipped over the railing, coming to rest with the back-end hanging precariously outside the track over an 80-foot drop. During the car's entanglement with the barrier, a piece of guard rail pierced the car's hood, driver's seat, and left side door, slicing off Kagle's leg. Here we see emergency crews tending to the injured driver and preparing him for transport to Cabarrus County Hospital. (Robinson-Spangler Carolina Room, Public Library of Charlotte and Mecklenburg County.)

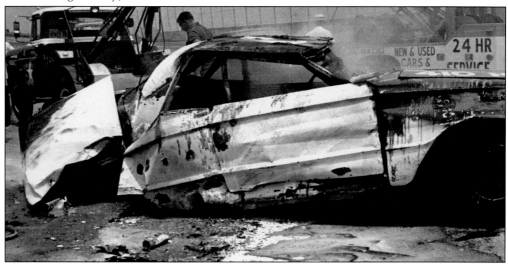

In the seventh lap of the 1964 World 600, Glenn "Fireball" Roberts's "Passino Purple" No. 22 Ford Galaxie tangled with Junior Johnson's car and then Ned Jarrett's before slamming into the third-turn wall and bursting into flames. Jarrett scrambled out of his own burning car and pulled Roberts from his blazing vehicle. Forty days later, on July 2, Roberts was dead from his injuries. (*Charlotte Observer.*)

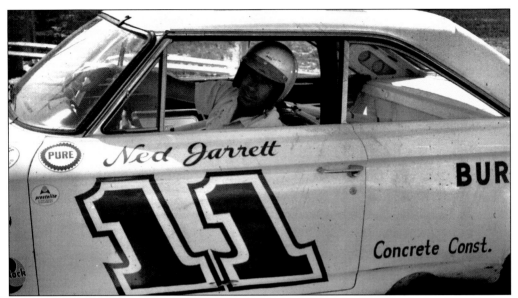

Ned Jarrett grew up working on his father's farm and sawmill in Newton, North Carolina. Despite his parents' opposition to his racing, Ned participated secretly under a pseudonym until he won a 1952 race at the Hickory Motor Speedways. In 1959, a young Ned wrote a check for $2,000 on a Friday after the banks closed to buy a Grand National car, counting on his winnings at that weekend's races in Myrtle Beach and the Charlotte Fairgrounds to cover it. Even though these were his very first attempts at Grand National racing, Jarrett won both events with severely bloodied and blistered hands and with help from Junior Johnson in relief. In all, Ned ran 348 Grand National series races, winning 50. Jarrett won the 1965 Southern 500 14 laps ahead of the second place finisher, still a record today. "Gentleman Ned" retired on top the next year. (History Room, Charles A. Cannon Memorial Library, Kannapolis Branch.)

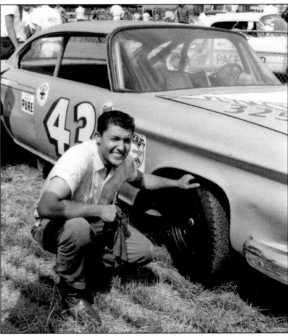

Seen here after winning the pole for the Second Annual World 600 in Charlotte, Richard Petty came to dominate the sport in the 1960s. His best year was 1967, when he won 27 of 48 races—including a record 10 in a row—and finished second 7 times in cruising to the championship. That year he led 41 of the 48 races. Of the 12,739 laps he completed, 5,537 were leading the field. (Robinson-Spangler Carolina Room, Public Library of Charlotte and Mecklenburg County.)

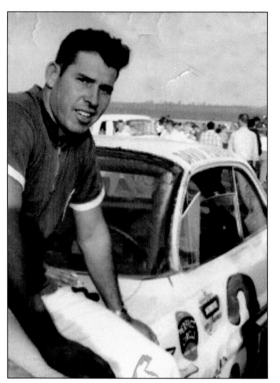

David Pearson, a Spartanburg, South Carolina native, learned about cars while working as a gas station attendant. Neither his humble beginnings, nor the fact that he had yet to win a race, prevented Pearson from attaining the Rookie of the Year award in 1960. His first big win occurred at the 1961 World 600 when, two miles from finishing, he blew a tire but didn't stop and drove the last two miles on the wheel rim with sparks flying. Pearson won 104 more races, the most of any driver except Richard Petty, and was named NASCAR Driver of the Century by Sports Illustrated. (International Motorsports Hall of Fame.)

Joe Weatherly was a very superstitious driver. He refused to associate himself with or dress in green, or drive a car that had any shade of green upon it. Weatherly was afraid of boiled peanuts, sold as a snack at nearly all southern race tracks—if he saw anyone eating peanuts, or even walk by with a bag of them, he would run away. Once some drivers played a joke on Joe by scattering peanut shells in his car prior to a race. He refused to get into his car until they were removed, and to make matters worse, Joe crashed during that race.

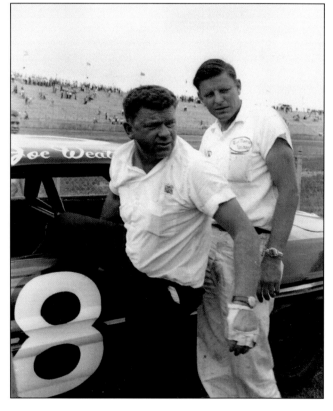

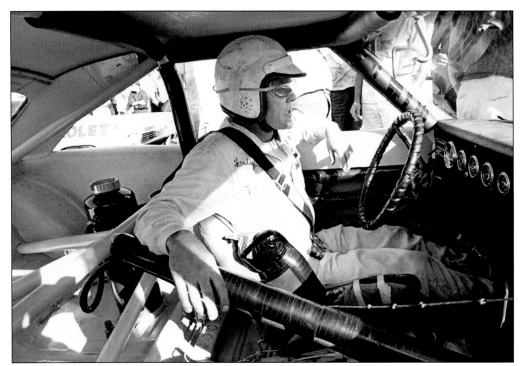

A native of Chicago, Fred Lorenzen explained the necessity of his move to Charlotte by saying, "The North was not race country. They didn't have any other sports down South like football and baseball back then. Racing was the big sport and people thrived on it." (*Charlotte Observer,* Don Hunter.)

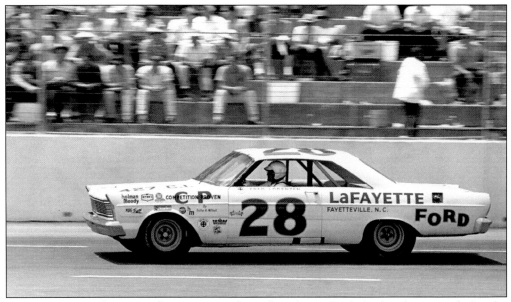

After barely scratching out a living as an independent driver, Fred's big break occurred when he joined the Holman-Moody team. His race winnings exploded from $235 in 1956 to $113,570 in 1963 and he dominated in the South like no other Yankee since General Sherman. (*Charlotte Observer,* Michael Mauney.)

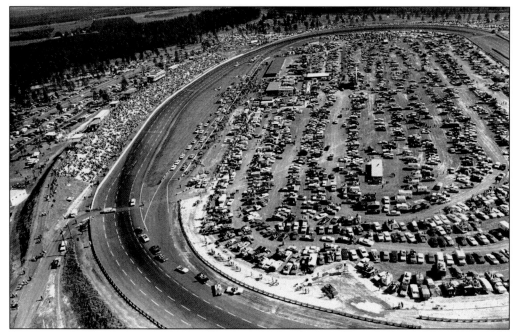

At its opening as a dirt raceway in Rockingham in October 1965, North Carolina Speedway was the site of Curtis Turner's first and only win after his 1961 "lifetime" suspension from NASCAR competition for attempting to form a driver's union. The track was paved and rebuilt in 1969 to just over a mile in length. (*Charlotte Observer.*)

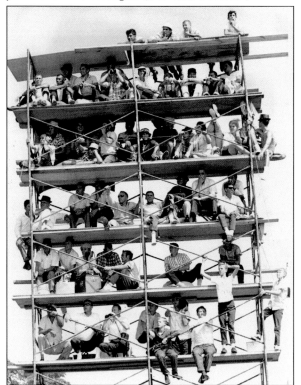

Who needs a ticket? These fans have erected a clever perch with an excellent view of the third and fourth turns of the 1964 Southern 500 at Darlington. Unfortunately for race promoters, the high tower is erected *outside* of the track's gates, and the view doesn't cost a thing. (*Charlotte Observer*, Hank Daniel.)

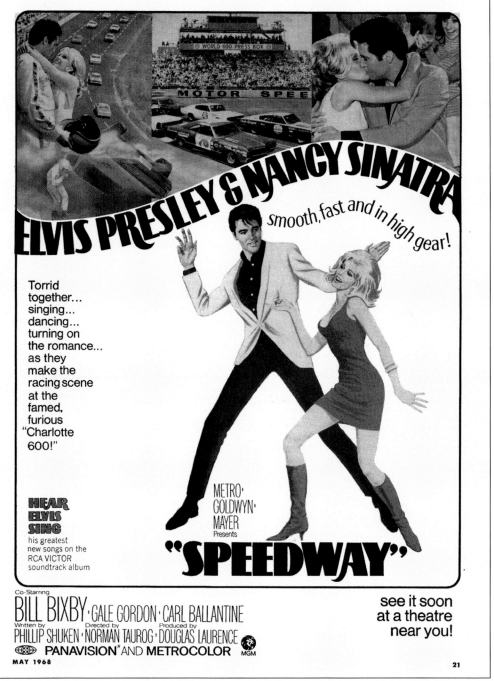

Elvis made two racing movies. *Speedway* (1968) featured Elvis as a singing race car driver whose manager makes some bad bets on the horses. Elvis is pursued by an IRS tax agent, played by Nancy Sinatra. Richard Petty, Buddy Baker, and Cale Yarborough, among others, had cameos. Racing scanes for the film were shot at the Charlotte Motor Speedway, but the King did not actually visit the city for filming. (Collection of Ryan Sumner.)

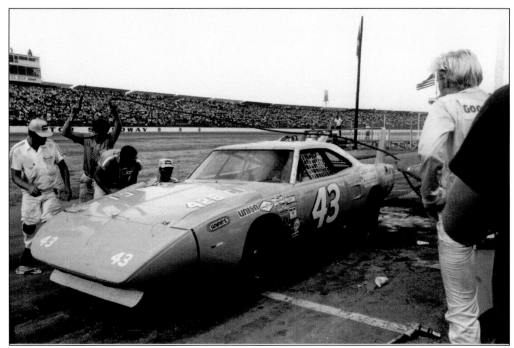

Richard Petty pulls his Plymouth Superbird into his pit during the 10th running of the World 600 in 1969. (Robinson-Spangler Carolina Room, Public Library of Charlotte and Mecklenburg County.)

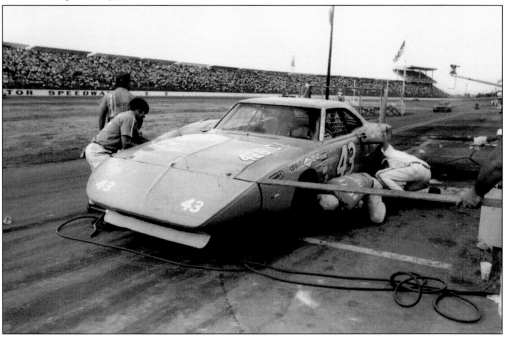

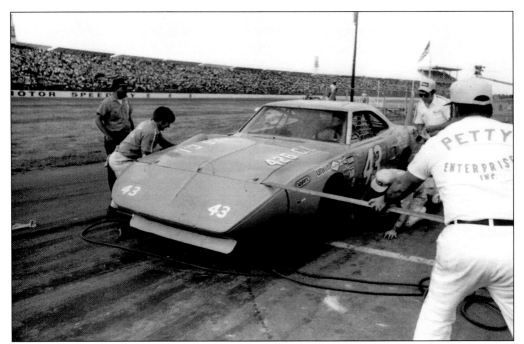

These photographs show the precision and coordination needed by a crack pit crew to get a car in and back out onto the race track in a matter of seconds. (Robinson-Spangler Carolina Room, Public Library of Charlotte and Mecklenburg County.)

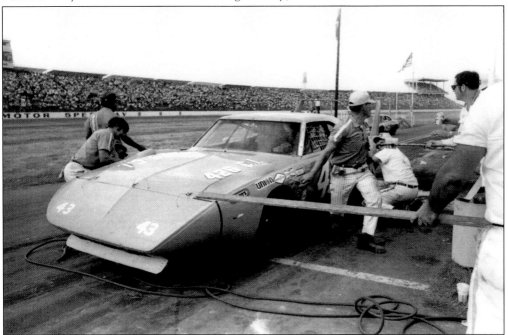

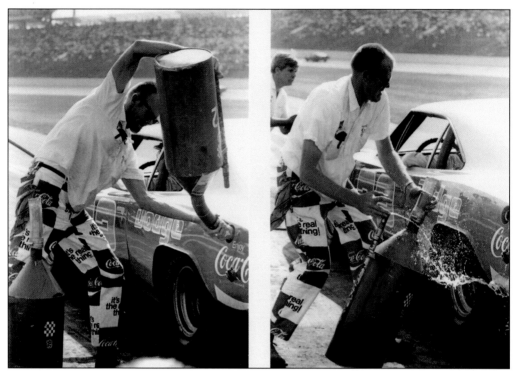

A gasman refuels Bobby Allison's 1970 Dodge Daytona, splashing himself greatly in the process. Nineteen years later in Atlanta, flames engulfed gasman Robert Calicutt when Richard Petty's car backfired. Today these crew members wear flame retardant suits and full-face helmets.

The driver is only the most visible member in what really is a team sport.

The son of a notorious Wilkes County distiller of illegal corn liquor, Junior Johnson learned to drive fast by making moonshine runs when he was just 14. Later Junior raced other top whiskey trippers at North Wilkesboro and began racing in NASCAR's top division in 1953. He continued bootlegging until the late 1950s, after spending 11 months in prison. (*Charlotte News*, May 22, 1965.)

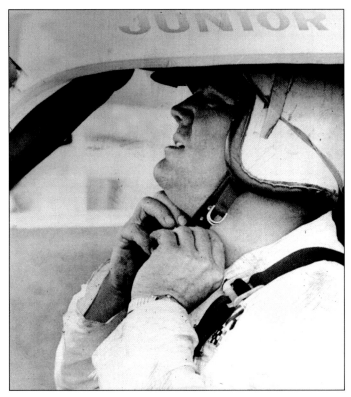

Johnson's racing career included 50 victories before he retired to become a team owner in 1966. Johnson's teams came into their glory years in the 1970s and 1980s, winning six championships in ten years, three each with Cale Yarborough and Darrell Waltrip. Junior's team almost won again in 1992, with driver Bill Elliott. (History Room, Charles A. Cannon Memorial Library, Kannapolis Branch.)

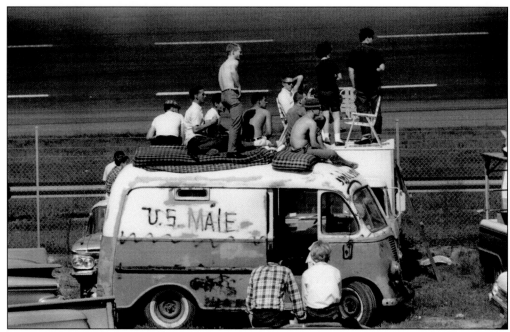

Fans on the infield get a good look at the action during the 1966 World 600. (Robinson-Spangler Carolina Room, Public Library of Charlotte and Mecklenburg County.)

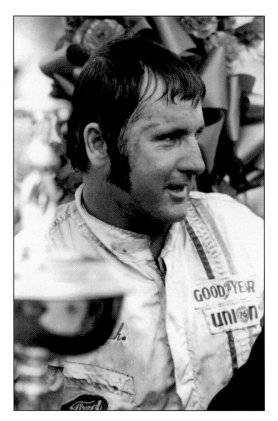

This is LeeRoy Yarbrough after winning the National 500 in Charlotte, October 1970. LeeRoy's racing career lasted a short 12 years. His most impressive season was 1969, when he won seven races, including the Daytona 500, the Southern 500, and the Coca-Cola 600 in Charlotte. He would have won the Winston Million for this feat, had the bonus prize been in place that year. However, Yarbrough crashed often and hard, shattering bones and sinking into alcoholism after developing a brain injury. He died at age 46 in a Florida mental hospital. (Robinson-Spangler Carolina Room, Public Library of Charlotte and Mecklenburg County.)

A native of Danville, Virginia (just over the North Carolina state line), Wendell Scott was a bootlegger discovered in 1949 by a race promoter searching police records for African Americans with speeding tickets. Scott soon made a name for himself on the dirt circuit in North Carolina and Virginia and moved up to NASCAR Grand National from 1961 to 1973. Facing constant racism, Scott had to protect his car from sabotage and was forced to draw a gun on Jack Smith during a race in Winston-Salem to keep him from maliciously bumping him. (*Charlotte Observer*, Bill McCallister.)

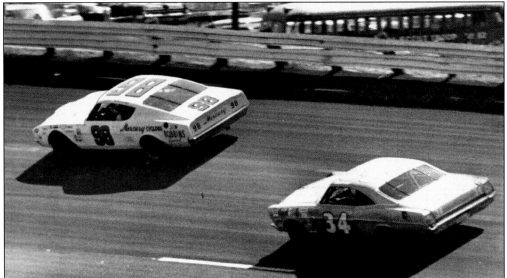

Wendell Scott's No. 34 car is passed by eventual race winner LeeRoy Yarbrough during May 1969's running of the Rebel 400 at Darlington. Scott ran in almost 500 races for NASCAR and was even ranked 9th in points for 1968 and 1969. Scott's only major win occurred in 1964 in Jacksonville, where the score-keepers declared Buck Baker the winner and didn't realize the "mistake" until after Miss Florida had kissed the supposed victor, the trophies had been awarded, and the crowd had gone home. (*Charlotte Observer*, Joe Tyner.)

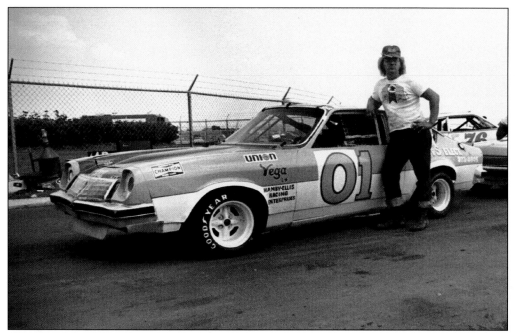

Charlotte Motor Speedway hosts more than just Winston-Cup Grand National racing. This gentleman works for Hamby Electrical Contractors during the week, but becomes the driver for Hamby-Ellis Racing Enterprises's Vega race car "sponsored" by his company. (Robinson-Spangler Carolina Room, Public Library of Charlotte and Mecklenburg County; Jim Wilson.)

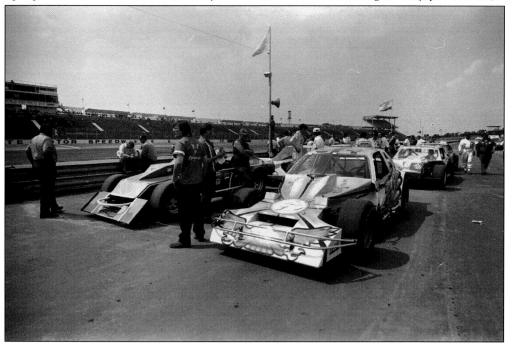

Here a group of weekend warriors gets set up for a Modified race at the speedway in late May, 1976. (Robinson-Spangler Carolina Room, Public Library of Charlotte and Mecklenburg County; Jim Wilson.)

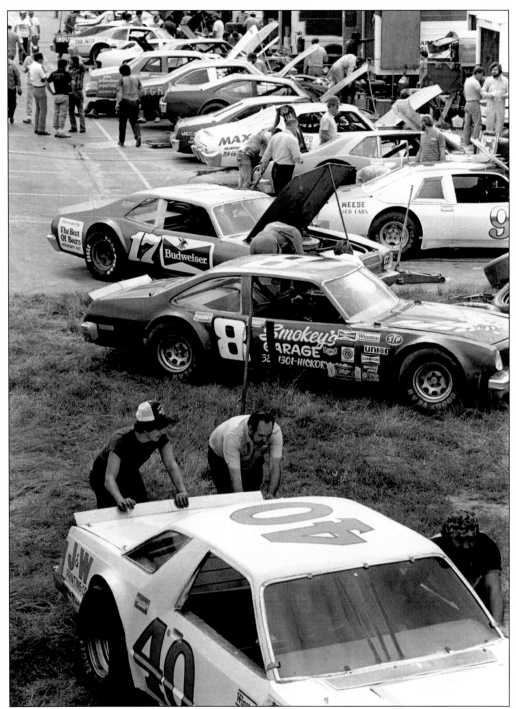

At an early 1980s Sportsman competition, teams finish preparing their cars and roll them to the staging area. Most of these people were not full-time professionals competing at NASCAR's highest levels. For these crews it would be back to work at their "real" jobs on Monday. (Robinson-Spangler Carolina Room, Public Library of Charlotte and Mecklenburg County.)

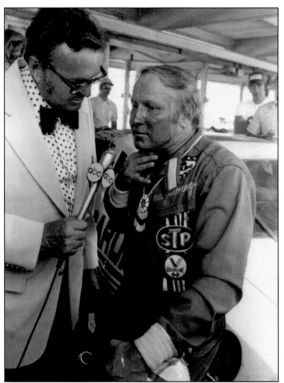

Cale Yarborough of Timmonsville, South Carolina talks to a correspondent from ABC Wide World of Sports after the 1974 National 500 in Charlotte. His car owner, Junior Johnson, often said, "When you strap Cale into the car, it's like adding 20 horsepower." One of the most accomplished Winston Cup drivers, Cale won the championship three consecutive years, from 1976 to 1978. He was known to his friends as a daredevil, who loved a challenge, and would try just about anything—sounds like the perfect personality for a race car driver! (Robinson-Spangler Carolina Room, Public Library of Charlotte and Mecklenburg County.)

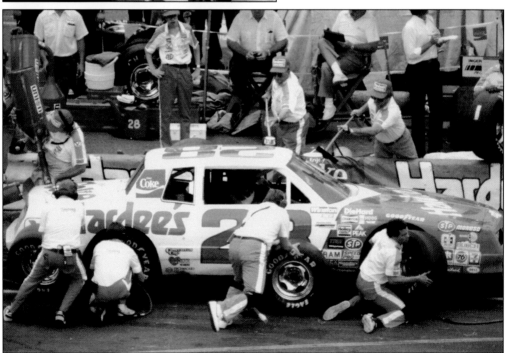

Cale Yarborough brings his Hardee's-sponsored Monte Carlo into the pits for two right-side tires and some gas during Charlotte's 1984 Miller High Life 500. (Robinson-Spangler Carolina Room, Public Library of Charlotte and Mecklenburg County.)

Beauty queens have played a major role in automobile racing since its early days. Races were often linked to county fairs and small-town Fourth of July celebrations, which featured local beauty contests, and the association likely began as the contest winners participated in the race's opening and closing ceremonies. Here a beauty queen rides in a pre-race parade around Charlotte's Speedway in 1961. (Robinson-Spangler Carolina Room, Public Library of Charlotte and Mecklenburg County.)

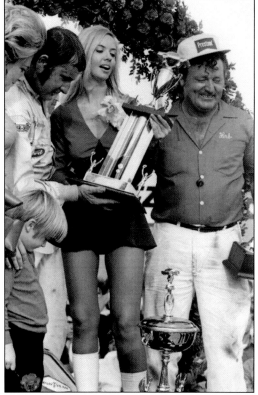

One of the main duties of race queens is to present race winners with their trophies and to kiss them in reward of their valiant behavior, like the kisses given to knights errant on the jousting field. Here we see Miss Falstaff Beer congratulating LeeRoy Yarbrough and crew chief Herb Thomas at Charlotte in 1970. (Robinson-Spangler Carolina Room, Public Library of Charlotte and Mecklenburg County.)

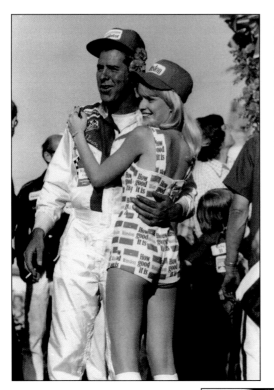

Many women have bristled at the objectified role of the prize-bearing beauty queen and believe it to be a barrier to competitive female participation to the sport. Here we see Miss Winston with David Pearson after his winning of an October 1974 race in Charlotte. (Robinson-Spangler Carolina Room, Public Library of Charlotte and Mecklenburg County.)

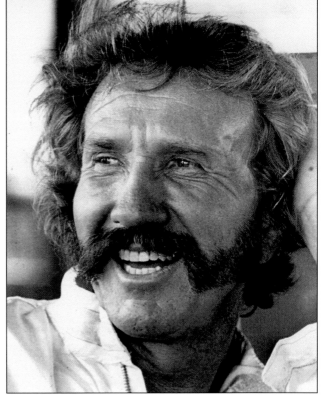

Marty Robbins began racing in 1965 and continued until his death in 1982. Never letting the competition get to him, he raced simply for fun. Robbins was a successful Western singer, whose hits like "Old El Paso" financed his racing career. The *Grand Ole Opry Show* always scheduled him as the last performer because he would use the occasion to enter a race at the Nashville Speedway and come to the show straight from the track. (*Charlotte Observer.*)

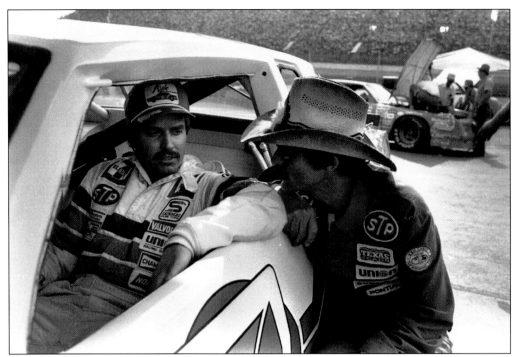

Third-generation driver Kyle Petty gets some advice from his famous father Richard before heading out on to the race track to practice for the 1983 World 600. (Robinson-Spangler Carolina Room, Public Library of Charlotte and Mecklenburg County; Mark Sluder.)

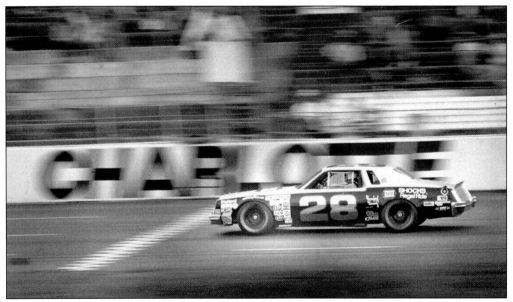

Here another driver carries on the family business. Buddy Baker, son of Buck Baker, sets the pole position at a then-record speed of 165.635 mph in 1980. (*Charlotte Observer*; Don Hunter.)

Harry Gant began racing at Hickory Speedway, where he found success driving hobby cars and late models in 1964. By the early 1980s, Harry had moved up the ranks to the Winston Cup. Known throughout the NASCAR community as "Handsome Harry," Gant was renamed "Mr. September" for winning four consecutive NASCAR Winston Cup races in September 1991, tying the record. Born in 1940, Harry's greatest successes were achieved against men nearly half his age. (Robinson-Spangler Carolina Room, Public Library of Charlotte and Mecklenburg County; Mark Sluder.)

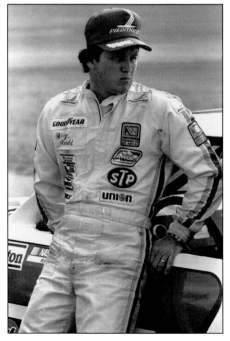

Driver Ricky Rudd's ride was sponsored for a time by Piedmont, a major airline based in Charlotte and one of the Queen City's largest employers at the time. (Robinson-Spangler Carolina Room, Public Library of Charlotte and Mecklenburg County; Mark Sluder.)

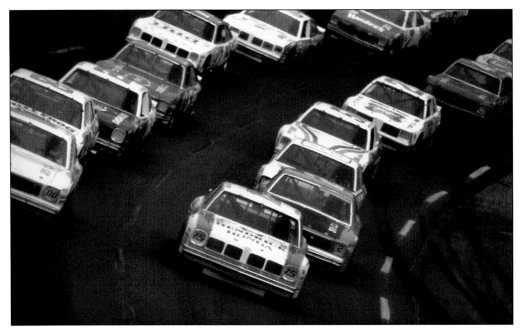

Coming around to start in October 1984, Geoff Bodine's Hendrick Honda car is out in front. This was the first year Charlotte-based car dealer Rick Hendrick fielded a team in NASCAR. In the 1980s and 1990s, Hendrick Motorsports became what Holman-Moody was in the 1950s and 1960s by combining talented drivers with the pursuit of engineering excellence. Drivers like Geoff Bodine, Tim Richmond, Terry Labonte, and Jeff Gordon became superstars driving for this team. (Robinson-Spangler Carolina Room, Public Library of Charlotte and Mecklenburg County.)

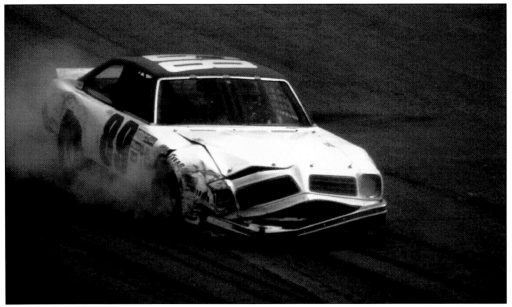

Busch Grand National driver Tom Peck's Pontiac limps back into the pits after an accident in the Miller Time 300 on October 6, 1984. (Robinson-Spangler Carolina Room, Public Library of Charlotte and Mecklenburg County.)

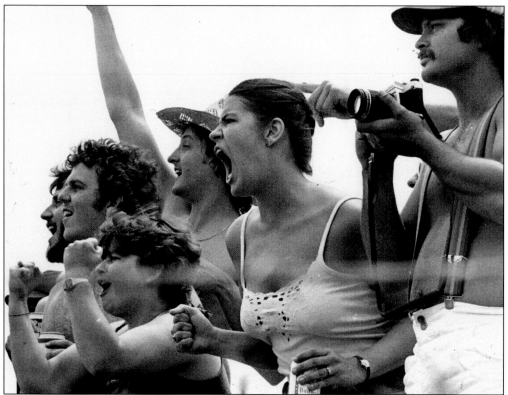

Here are a group of enthusiastic young fans at the World 600 in Charlotte, 1980. (*Charlotte Observer*, Tom Franklin.)

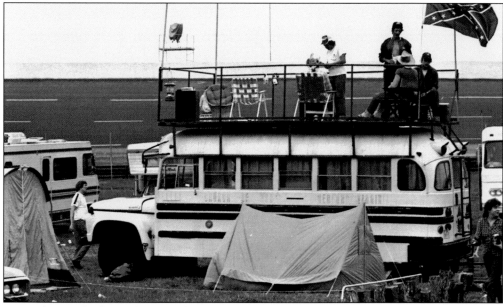

"I stand atop the bus. The infield is one huge party, a roaring Dionysian revel. It's redneck Woodstock, a gear head Grateful Dead concert," said journalist Peter Carlson. (Robinson-Spangler Carolina Room, Public Library of Charlotte and Mecklenburg County.)

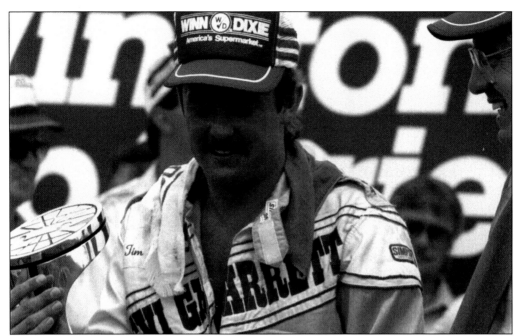

Tim Richmond's NASCAR career lasted only seven years, but in that time he made an impact. In 1986 Tim won seven races, more than any other driver, and finished third in the Winston Cup points race. His fast driving on the track was rivaled by his fast living off the track, including womanizing and alleged cocaine use. By 1989, Richmond was dead of complications from AIDS. Many criticized NASCAR's behavior toward Richmond during his times of trouble, which included cover-ups, information stonewalls, and harassment of Richmond. (Robinson-Spangler Carolina Room, Public Library of Charlotte and Mecklenburg County.)

Largely filmed at the Charlotte Motor Speedway, *Days of Thunder* was based on the relationship between Tim Richmond and legendary crew chief Harry Hyde. Richmond came into NASCAR as an Indy-car driver with no stock car experience, but Hyde turned him into the hottest driver on the circuit. Because Hendrick Motorsports oversaw much of the script and served as technical advisors, many scenes from the film are based on actual events from Hendrick's history, such as the challenges of managing a two-car team, convincing a veteran crew chief to come out of retirement, the 50-lap tire test, and the "airport scene" where Cruise (Richmond) crushes the front of a cab with his rear bumper. To capture an authentic feel, Hendrick outfitted several stunt cars with cameras and ran them during actual NASCAR races to capture footage. (Hendrick Motorsports.)

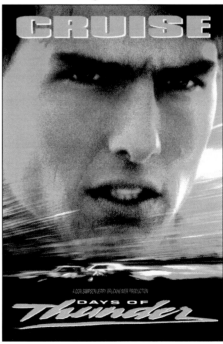

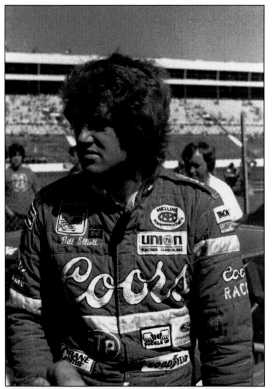

Bill Elliott, a Dawsonville, Georgia native, made his Winston-Cup debut at North Carolina Motor Speedway in 1976. Seen here in Charlotte in the mid–1980s, Elliott was one of the most popular drivers of the decade and got the nickname "Million Dollar Bill" in 1985 for winning the R.J. Reynolds $1 million bonus for victories at the Daytona 500, the Winston 500 at Talladega, and the Southern 500 at Darlington. The now 48-year-old driver is not concerned about the younger generation of hot-shots in his rearview mirror: "When I first came up, David Pearson, the Pettys, the Allisons, they all looked at me like 'Who the heck is this kid?' It comes in cycles, and we're in the middle of one right now. But there'll be another one after this. There's no use worrying about it." (Robinson-Spangler Carolina Room, Public Library of Charlotte and Mecklenburg County.)

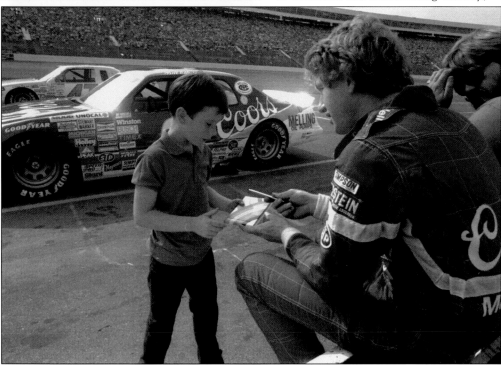

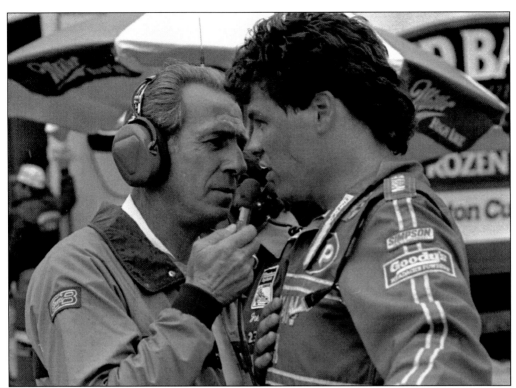

After retiring from driving, Ned Jarrett built an impressive career as a race announcer. He has called races for both CBS and ESPN and hosts *Inside NASCAR* on TNN and a syndicated radio show distributed by the Motorsports Racing Network. Here he interviews Mike Waltrip after Waltrip's car did not finish a race in 1986. (*Charlotte Observer*, John Cleghorn.)

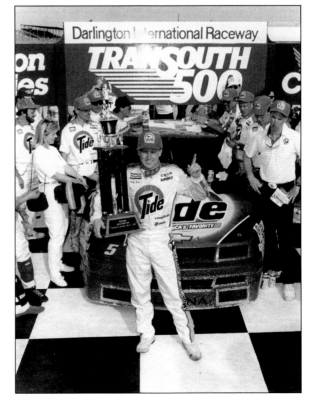

By the early 1990s, NASCAR was the fastest growing sport in America, surpassing all other American spectator sports except football. Corporate America noticed this exploding fan base, and all sorts of companies began to sponsor race teams. Tide Detergent, which traditionally sought female buyers with commercials during daytime soap operas, was the first to break the mold. Now everyone—from UPS to the Cartoon Network—has a car! (Hendrick Motorsports.)

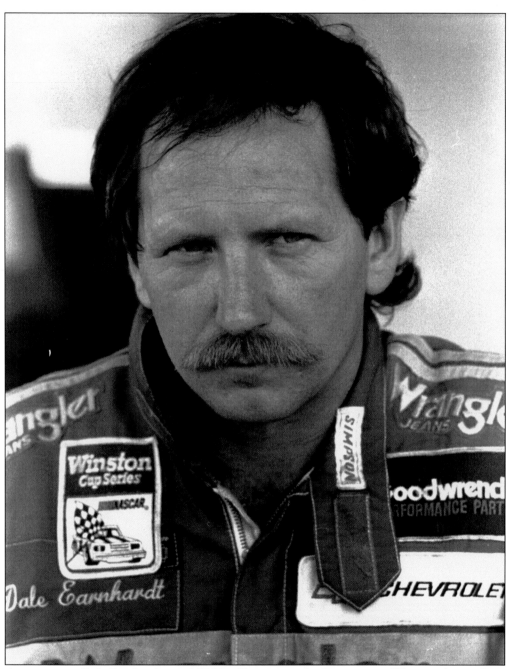

As a teenager, Dale Earnhardt raced Hobby Class cars in his hometown of Kannapolis, working days and racing or working on his cars at night. Later he would make a name for himself while driving Sportsman-level at the Concord and Hickory Speedways and Metrolina Fairgrounds. He made his Winston Cup debut in 1975, but he didn't run full-time until four years later. Dale would win the first of his eventual eight championships in 1980. Dale's career exploded when he joined Richard Childress's race team in 1984. Together the pair won nearly every major event and title available to NASCAR Winston Cup drivers. (Robinson-Spangler Carolina Room, Public Library of Charlotte and Mecklenburg County.)

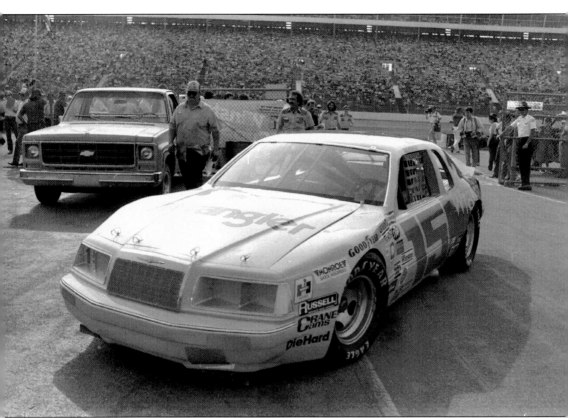

Dale Earnhardt is closely associated with driving Chevrolets emblazoned with the number 3, but few remember that "The Intimidator" used to drive a Ford Thunderbird for Bud Moore in the early 1980s. (Robinson-Spangler Carolina Room, Public Library of Charlotte and Mecklenburg County.)

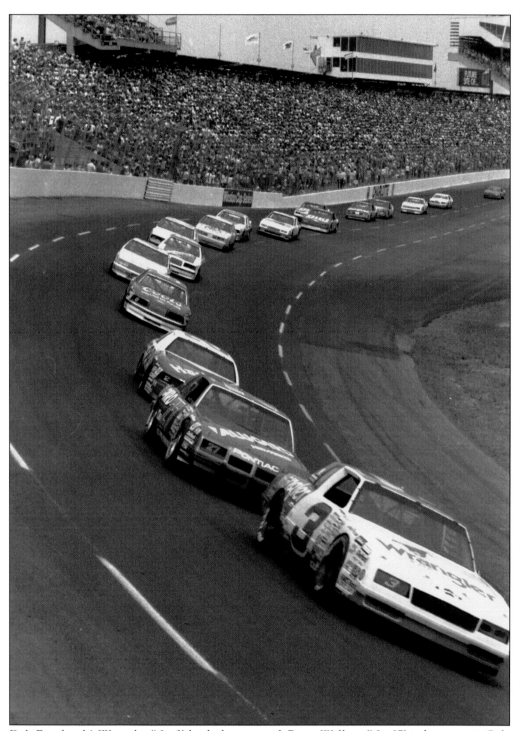

Dale Earnhardt's Wrangler (No. 3) leads the way, with Rusty Wallace (No. 27) in hot pursuit. Cale Yarbourgh (No. 28) and Bill Elliott (No. 9) nip at the leader's heels during the May 1986 Coca-Cola 600. (Robinson-Spangler Carolina Room, Public Library of Charlotte and Mecklenburg County, Candace Freeland.)

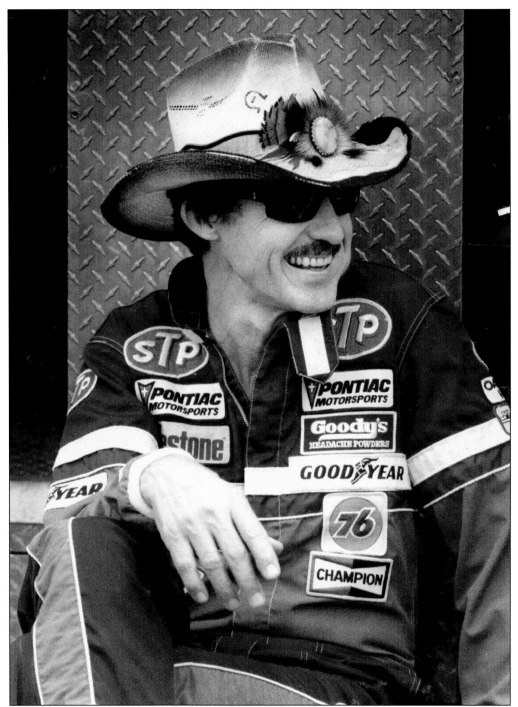

Richard Petty is justly referred to by NASCAR fans as "The King." Born in Randleman, North Carolina, Petty surpassed his father Lee's considerable accomplishments, winning 200 Winston Cup races and taking the Winston Cup points championship seven times. With his trademark sunglasses and hat, he is one of the most recognizable figures in the Piedmont. (*Charlotte Observer*, Wes Bobbitt.)

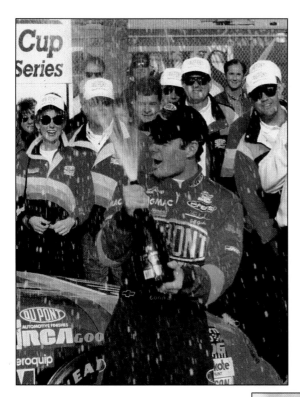

Jeff Gordon made his Winston Cup debut during Richard Petty's last race in 1992, the same year he began racing for Hendrick Motorsports. For many long-time NASCAR fans, Jeff Gordon represented a change in the sport. He wasn't Southern—from California, no less—and had a privileged background that allowed him to race from the time he was a child. Fans who saw in men like Dale Earnhardt and Darrell Waltrip a reflection of their own working-class lives, found little to identify with in Gordon. At the same time, Gordon was instrumental in expanding NASCAR's fanbase outside the South. (Hendrick Motorsports.)

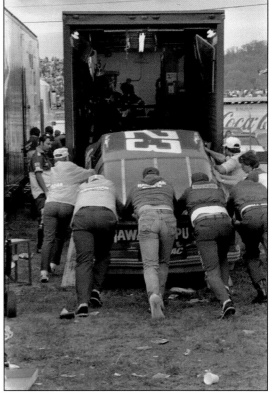

It is the end of the day after a race. The winner is crowned, and feelings of disappointment turn to hope for victory in the next weekend's contest. (Robinson-Spangler Carolina Room, Public Library of Charlotte and Mecklenburg County.)

Four

WOMEN IN A MAN'S GAME

For years, women's attempts to race have been perceived as publicity stunts, and female drivers have not been taken seriously as competitors. This advertisement from the mid-1960s illustrates this point: the only thing more amazing than Mustangs driven on two wheels or jumped over parked buses is that the pilots of the cars are all women. Since the beginning of stock car racing in the South, only a few brave women have challenged gender conventions in a traditionally male sport. In fact, only 15 women have started a Winston Cup Grand National Race since 1949—not even half as many women as NASA has sent into space since 1984. (*Charlotte Observer.*)

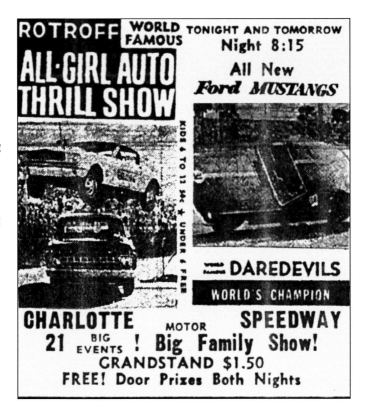

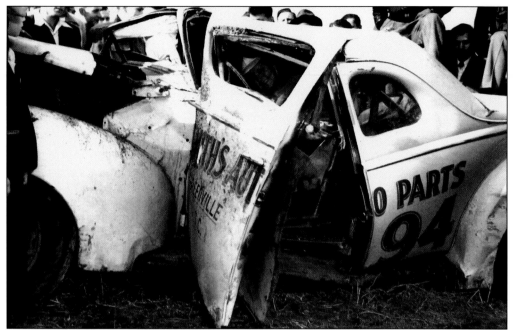

Louise Smith of Greenville, South Carolina, actually drove in the first stock car race she ever saw, which was in 1946, and continued for the next eight years. She was known for the aggressive driving and spectacular crashes that defined her decade of racing. In 1949, Louise Smith's car crashed into the Eno River at Occoneechee Speedway in Hillsborough. When it was pulled out, it took an hour for the rescue squad to get her out. After the race, she needed 48 stitches and four pins in her knee. (Lowe's Motor Speedway Archives.)

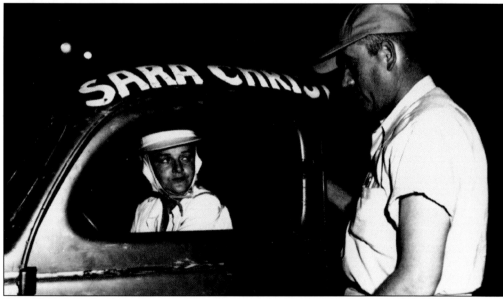

Sara Christian raced in the first "Strictly Stock" race in Charlotte in 1949, finishing 14th. Sara was one of three female drivers—along with Ethel Flock and Louise Smith—who raced in NASCAR's early days. According to Ethel's brother Tim, "all three could broadside the car like a man." (Lowe's Motor Speedway Archives.)

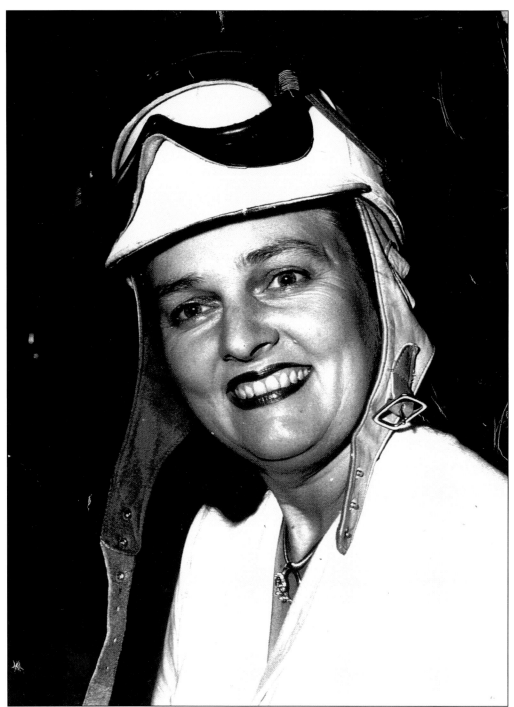

Ethel Flock Mobley, sister of famed dirt-track demons Bob, Fonty, and Tim Flock, was named after the fuel her father put in his cab, and it certainly proved a prophetic choice. Ethel participated in more than 100 dirt racing events, mostly in her native Georgia to remain close to her daughter, but family members recall her competing in many races at the Southern States Fairgrounds and the Charlotte Speedway off Wilkinson Boulevard. (Courtesy of Frances Flock.)

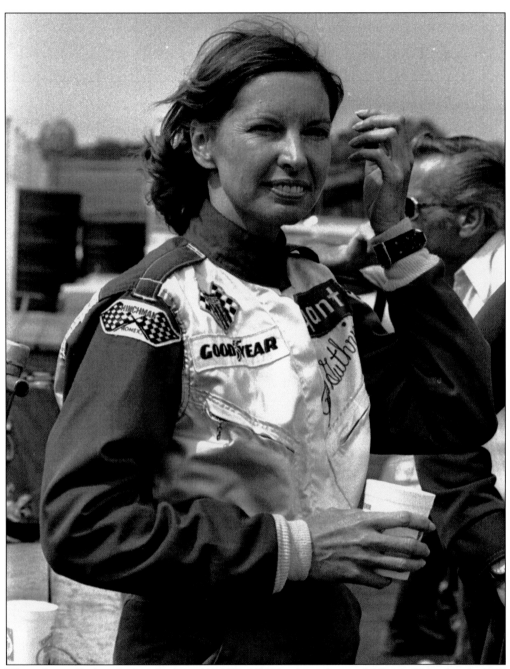

This is Janet Guthrie before the May 1976 World 600, where she would finish 15th, ahead of Bill Elliott and Dale Earnhardt. "It was my most taxing race physically, but an absolutely fantastic experience," she later said. Guthrie, the most prolific female driver in Winston Cup racing, participated in 33 Grand National events from 1976 to 1980 and fashioned 5 top-10 finishes, including a sixth-place effort at Bristol in August of 1977. She is the only woman ever to lead a race, doing so for five laps at the old Ontario (California) Speedway in November of 1977, and she is also one of the few women ever to race in the Indianapolis 500. (Robinson-Spangler Carolina Room, Public Library of Charlotte and Mecklenburg County.)

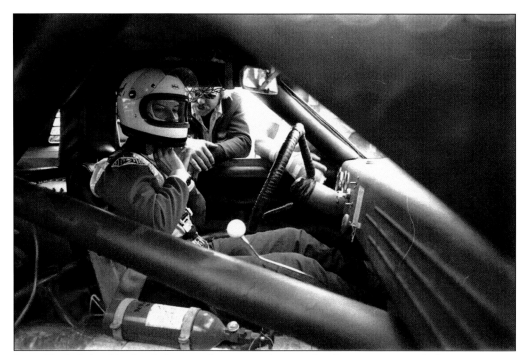

Janet Guthrie buckles her helmet and gets some last words of encouragement before attempting to qualify for pole position at the 1976 World 600 in Charlotte.

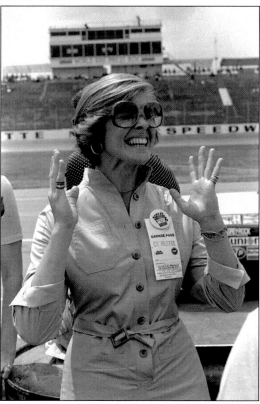

Lynda Ferreri, a First Union National Bank vice president and owner of the Kelly Girl–sponsored Chevrolet, expresses her excitement as her driver Janet Guthrie qualifies the car at Charlotte Motor Speedway in 1976. Ferreri, who was involved in the women's movement in Charlotte, bought the car from Donnie Allison and a new engine from Ralph Moody to silence people who doubted a woman's ability to compete in stock car racing. Guthrie drove for Ferreri on the Winston Cup circuit through 1977. (*Charlotte Observer*, Jim Wilson.)

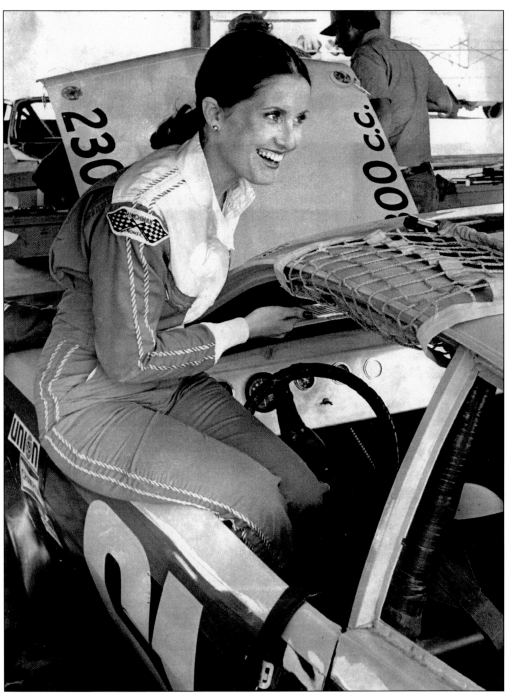

Lillian Vandiver gets out of her race car after making a practice run on Charlotte Motor Speedway in May 1976. Starting out in powder-puff races at Metrolina Speedway, she soon moved onto the Baby Grand sub-compact division. On this day, she had little problem taking the car up to 125 mph and finishing second only to David Combs, who had won nine Baby Grand races in the prior two years. Just before taking off, she quipped to a reporter, "This has nothing to do with feminism. I've loved racing all my life." (*Charlotte Observer*, Don Hunter.)

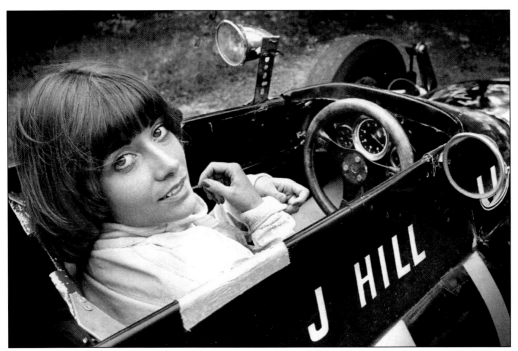

Sylvia Thompson, a Hickory dental hygienist, is pictured behind the wheel of her "Tooth Fairy Special" Formula V race car, after driving it to victory in August 1976 at the Charlotte Motor Speedway. She thus became the first woman to win an auto race of any kind at the one-and-a-half-mile oval. Sylvia started out in drag racing, once turning a Ford Pinto into a ride known as "the fastest car in Mooresville." (*Charlotte Observer*, Martin Rose.)

Kelly Drinkard of Charlotte started out running parking lot races and seemed on the verge of a breakout career in the mid-1970s. She came in second at a 1976 regional race at Charlotte Motor Speedway, ran in the Chimney Rock Hill Climb, and participated in an endurance contest at Summit Point, West Virginia with driving partner Anne Kincaid. "I never thought I'd be scared," she remarked, "but in that race in Charlotte, I got out there on the banks at about 139 miles per hour, and I started to wonder. I thought, 'What am I doing here?' But you're not afraid of death. You wouldn't be doing this if you were." (*Charlotte Observer*.)

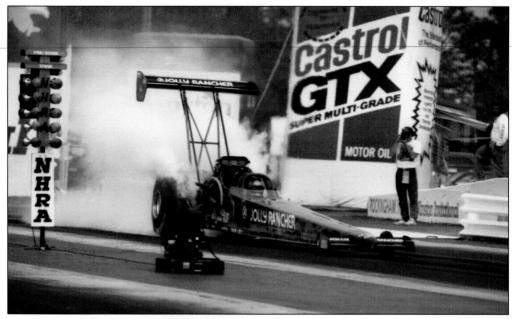

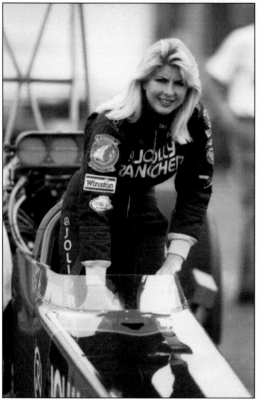

Here Lori Johns races her Jolly Rancher Top Fuel car at Rockingham in April 1991, where she placed second. Johns has won four national NHRA Drag Racing events and is one of only six women—including Angelle Savoie (22 wins), Shirley Muldowney (18), Shelly Anderson (4), Lucille Lee (1) and Christen Powell (1)—to win one. Lori became entangled in controversy during the mid-1980s, when she sued driver Kenny Bernstein and his sponsor Budweiser over a two-car accident that happened when she was racing in a competition eliminator. Deserved or not, the nickname "Lawsuit Lori" was given to her by those who worried that the suit could ruin the sport. (Robinson-Spangler Carolina Room, Public Library of Charlotte and Mecklenburg County.)

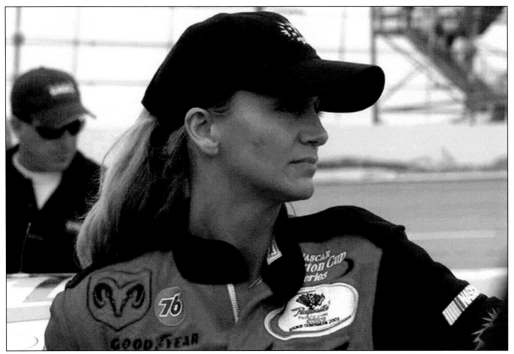

Shawna Robinson has been a successful NASCAR driver by any standard. After starting in Great American Truck Racing in 1984, she moved on to the NASCAR Dash series where, at the New Asheville Speedway in 1988, Shawna was the first woman to win a touring series event. The next year, she was the first woman to win a pole position, at I-95 Speedway in Florence, South Carolina. Recently, she was the first woman to finish a Winston Cup race since Janet Guthrie did it in 1980. (Alan Vordermeier Jr., Performance 1 Racing.)

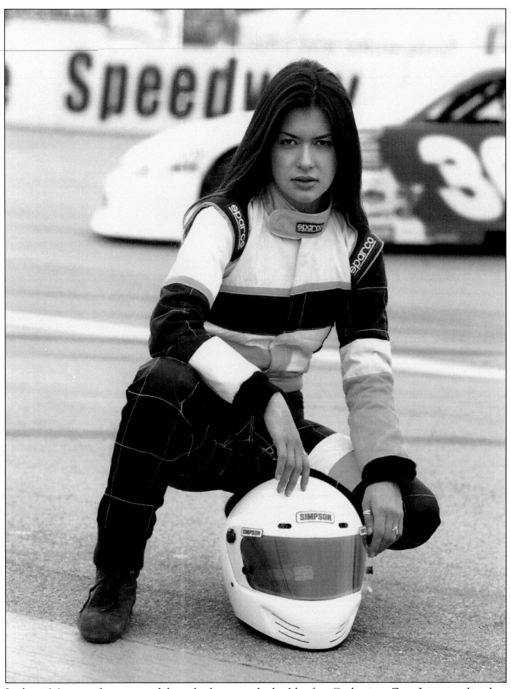

Leilani Münter, former model and photograph-double for Catherine Zeta-Jones, splits her time between instructional duties at the Richard Petty Driving Experience and driving a late model stock car with Cliff Lakey Racing. She currently holds licenses in ARCA Panoz GT and NASCAR competition. (Chris Edwards, *Charlotte Magazine*.)

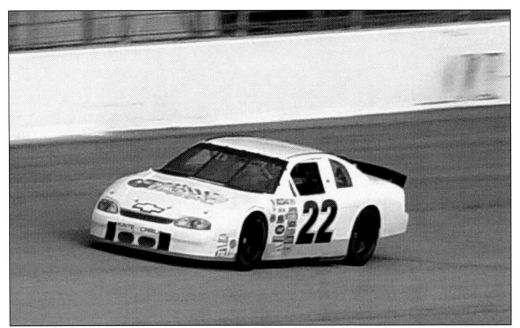

Münter rounds the fourth turn of Atlanta Motor Speedway, while training with former ARCA Champion Andy Hillenburg in 2002. "I belong at the track," she says. "When I'm driving, nothing else in the world matters. I can't explain . . . all I want to do is drive." (Courtesy of Leilani Münter; photo by Leo Dougherty and Donna Adams.)

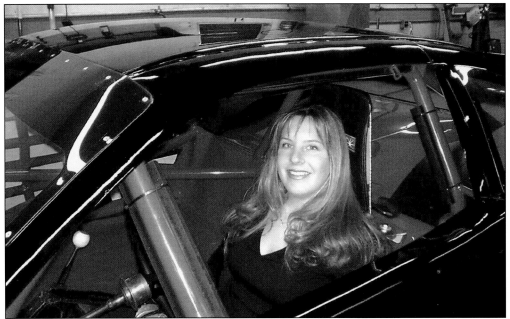

Trailblazing driver Lyn St. James named Allison Duncan as one of the stock car racers to watch in coming years. Duncan has three championships to her credit and many victories in cars like RX-7's and Vipers. The mechanical engineer moved to Charlotte recently and hopes to translate her successful and competitive career in sports car racing into stock car racing. Here she is in her late-model car, ready for a 2003 race at Hickory Speedway. (Courtesy of Allison Duncan.)

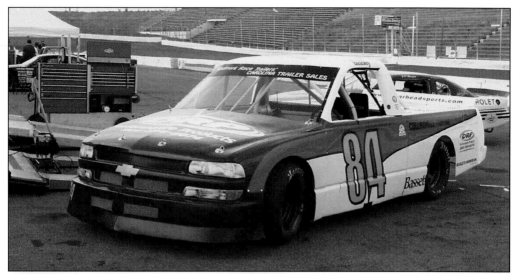

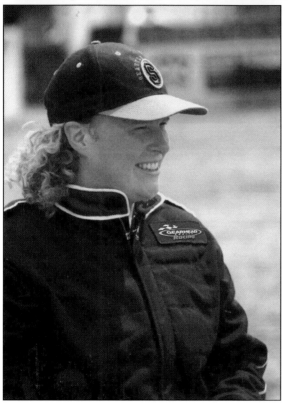

The participation of women in the sport of auto racing is much greater at the local level . Women compete on a regular basis at Piedmont dragstrips and smaller tracks. Marilyn Beasley began racing in the Pro Truck division in 1987, and was the first woman to win a feature event at Concord Motorsports Park, North Carolina. She finished in second place there in Season Points in 1999, driving a truck owned by Anne Croney, a furniture industry executive. (Courtesy of Gearhead Sports.)

Five

ON THE STRAIGHT AND NARROW

DRAG RACING AND MORE

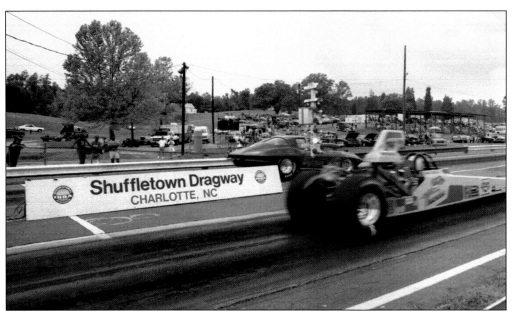

Ed Rankin and Scratch Whisnant opened Shuffletown Dragway, in the northwestern part of Mecklenburg County, in 1959. Illegal street drag racing had become a dangerous problem in Charlotte, and the city saw Shuffletown as a way to improve safety on the streets. It accomplished that, but by the early 1990s, Charlotte's rapid growth meant that Shuffletown was too close to the residential neighborhoods that were sprouting up everywhere. After a legal battle, the dragway closed in 1993. (Robinson-Spangler Carolina Room, Public Library of Charlotte and Mecklenburg County.)

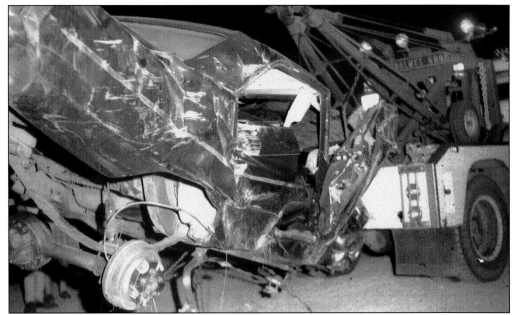

In the years after World War II, economic prosperity, population growth, and road construction created a car culture in Charlotte and the surrounding Piedmont region. Long, straight boulevards, access to automobiles, and maybe a little boredom conspired to make street racing popular among teens. The risks were great, however, and consequences were dire. In 1968, this car was totaled in a street racing accident in Kannapolis, and its teenaged driver killed. (History Room, Charles A. Cannon Memorial Library, Kannapolis Branch.)

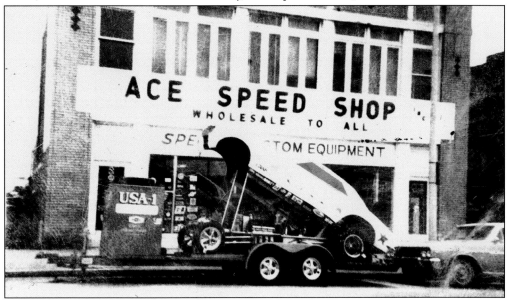

Drag racing legend Bruce Larson stopped at Charlotte's Ace Speed Shop at Trade and Tryon Streets to show off his USA-1 Funny Car in 1966. Larson, who competed over four decades, raced numerous time at Shuffletown and Mooresville. Larson pulled his car to races across the country on an open trailer, which is unthinkable today. Dominant in the 1960s, he would win the Winston Funny Car Championship as late as 1989. (Courtesy of Gerry Thalacker.)

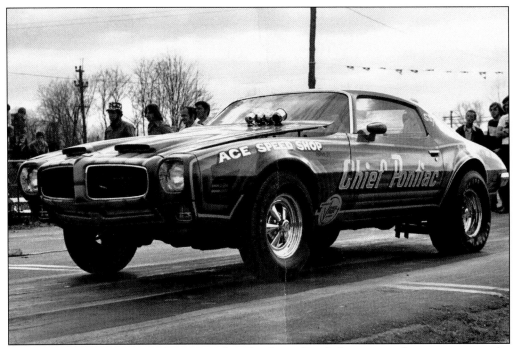

A brand new Pontiac Trans Am, entered in the Super Stock drag racing division, waits at the starting line at Shuffletown, 1972. (Courtesy of Gerry Thalacker.)

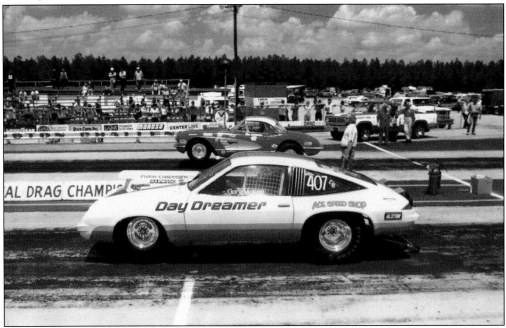

Gary McKee of Rock Hill (foreground) lines up in his Monza for a qualifying heat at the NHRA Spring Nationals at Rockingham Dragway in 1981. McKee and his teammates built the car from a kit, then worked with it until it started winning drag events. Gary, who runs a building materials company, raced in the Modified and Pro-Modified categories (among others) for 30 years. (Courtesy of Gerry Thalacker.)

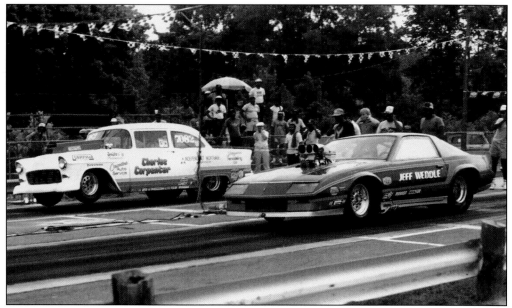

Charles Carpenter in his 1955 Chevy lines up against Jeff Weddle in a match race at Shuffletown in 1988. Carpenter, a garage owner from Charlotte, has never raced in anything but a 1955 Chevrolet since he began drag racing in 1972. With his cars, known collectively to fans worldwide as the "World's Fastest '55 Chevy," he has broken all kinds of records against all types of challengers. (Charles Carpenter.)

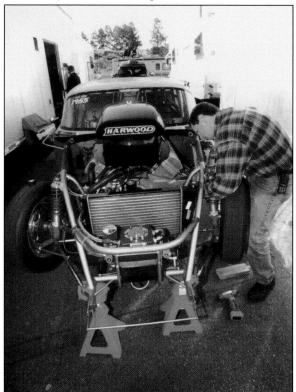

Pictured here is Charles Carpenter with his 1955 Chevy at Rockingham before the nationals in the 1980s. (Clark Racing Photography.)

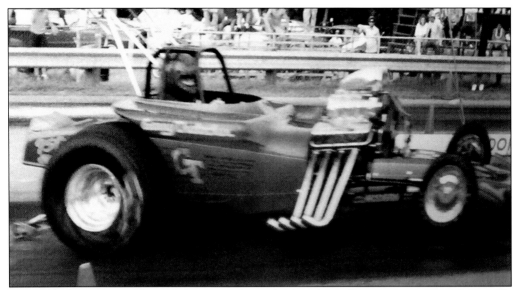

Gerry Thalacker is seen here in his Supercharged Altered Roadster competing at Mooresville Dragway in 1989. Gerry, based in Clover, South Carolina, moved to the Charlotte area from Wisconsin because of the racing culture. He was one of the top drivers in the Pro Funny Car Class, and he was ranked in the top 10 of the International Hot Rod Association World Points Standings several times. (Courtesy of Gerry Thalacker.)

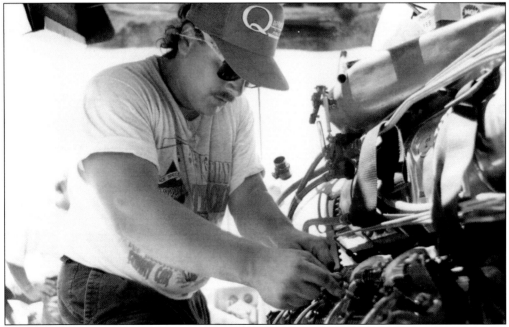

Thalacker makes last-minute adjustments to his Funny Car's engine before a race. On the outside, Funny Cars might look like cars you would see on the street, but underneath, they bear little resemblance. Most use an aluminum version of the powerful 426 Chrysler Hemi engine, which NASCAR has banned from its races, and they are fueled by nitromethane (which today costs more than $18 per gallon) rather than regular gasoline. Braking is enhanced by two parachutes on the back of the car. (Courtesy of Gerry Thalacker.)

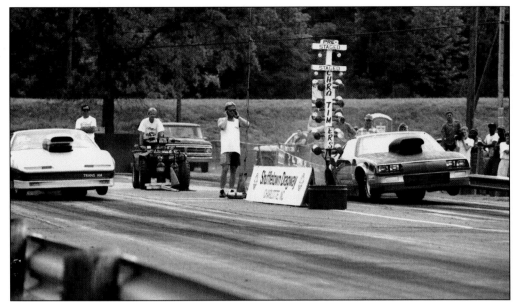

The torque of up to 4000 horsepower causes these two opponents to raise their tires at the starting line at Shuffletown, 1991. (Robinson-Spangler Carolina Room, Public Library of Charlotte and Mecklenburg County.)

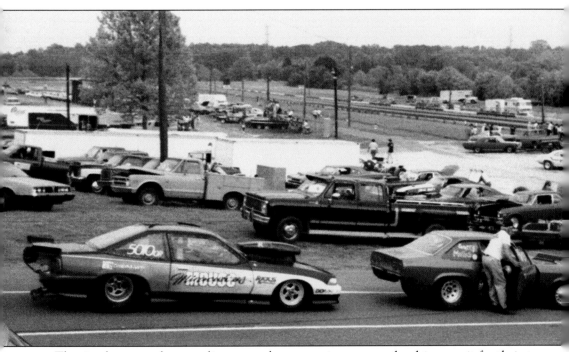

The ritual on race day: cars line up at the pre-staging area as the drivers wait for their turns at Shuffletown, 1991. (Robinson-Spangler Carolina Room, Public Library of Charlotte and

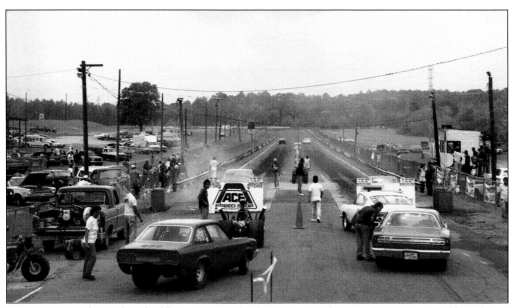

Here is a view down the Shuffletown strip. (Robinson-Spangler Carolina Room, Public Library of Charlotte and Mecklenburg County.)

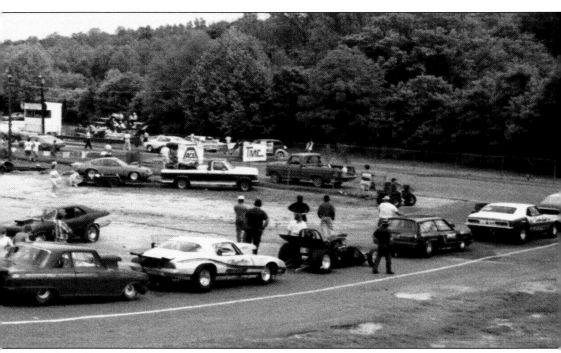

Mecklenburg County.)

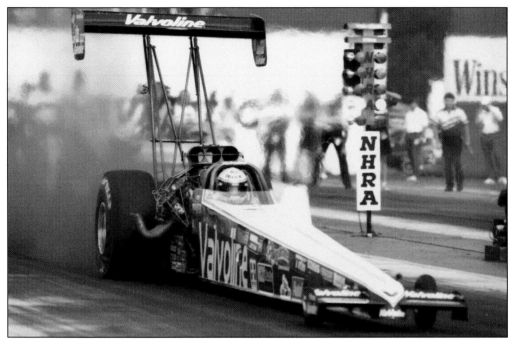

Rockingham Dragway, directly across from the North Carolina Speedway on U.S. Highway 1, opened in 1969. The largest dragway in North Carolina, Rockingham seats 25,000 and hosts the opening and closing events of the International Hot Rod Association's season. In this picture, Joe Amato, the most successful Top Fuel driver in NHRA history with five Top Fuel Championships, jumps on the green light to win the Winston Invitational in 1991. Amato was the first Top Fuel driver to exceed both 260 mph and 280 mph in the 1980s. (*Charlotte Observer*, Mark Sluder.)

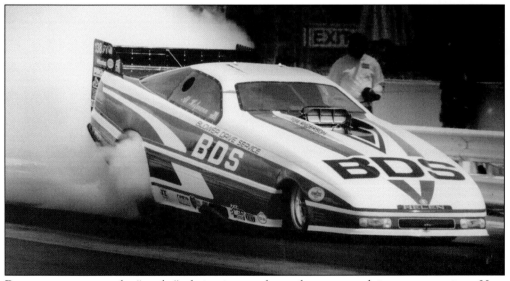

Drag racers commonly "smoke" their tires to heat them up and increase traction. Here Al Hoffmann does this prior to defeating the usually unbeatable John Force and winning the Funny Car division of the 1991 Winston Invitational at Rockingham. (*Charlotte Observer*, Mark Sluder.)

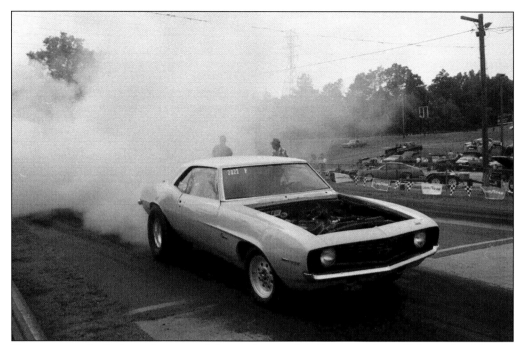

You can practically hear the roar of the engine as this Camaro takes off down the 1/8-mile dragstrip at Shuffletown.(Robinson-Spangler Carolina Room, Public Library of Charlotte and Mecklenburg County.)

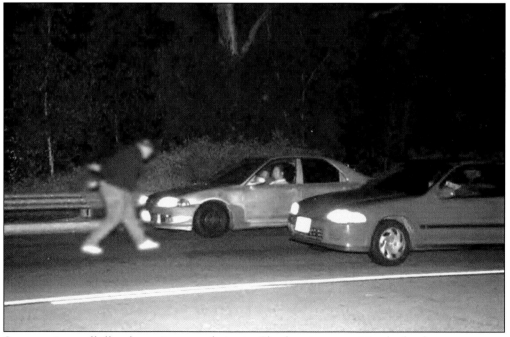

Street racing, still illegal, continues to thrive in Charlotte's streets. Hundreds of spectators may gather in the late night hours to watch, and bet on, street races. The drivers are unnamed, and the location is unidentified, as two Honda Civics get the signal to hit the gas pedal. (Photographer unknown.)

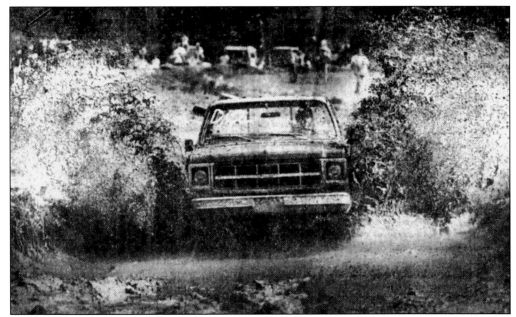

Here is a mudslingers competition at Clover, South Carolina in 1976. This event is often a drag-racing competition among four-wheel-drive vehicles through as much mud as they can find, but at Clover, the race was run on a mud oval, artificially created on a local member's farm by the Jaycees Organization. (Robinson-Spangler Carolina Room, Public Library of Charlotte and Mecklenburg County.)

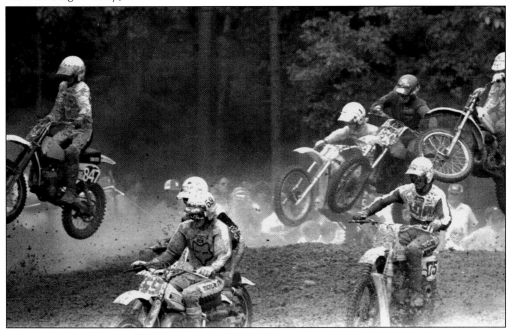

Motocross also has had a hard-core following at a number of venues around the Piedmont. Gaylon Moser, riding a Kawasaki, won two 125cc Class motocross events this day at Metrolina Speedway in 1978. (Robinson-Spangler Carolina Room, Public Library of Charlotte and Mecklenburg County.)

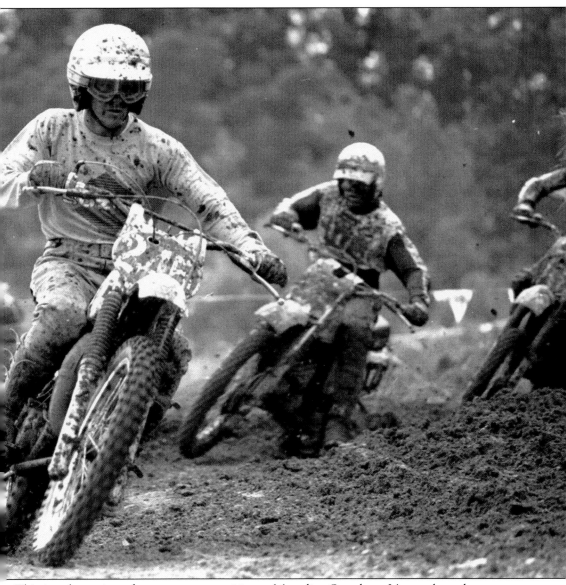

This is a closer view of motocross competition at Metrolina Speedway. It's not clear why anyone would have worn white while competing in this event.

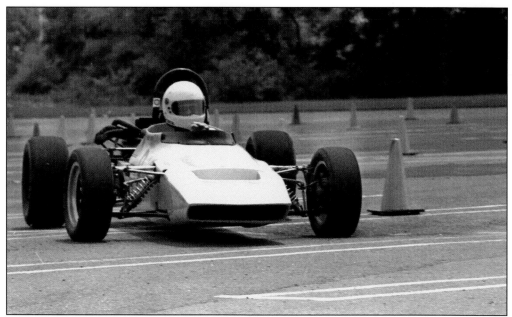

Smaller-scale events like autocross gave people with dreams of racing a chance to get out and show what they had. Henry Payne, pictured here in his Ford Elden PH at a Central Carolinas Region Sports Car Club of America autocross event at Charlotte's Eastland Mall, was a Duke Energy engineer when this photograph was taken in 1985. (*Charlotte Observer*, Nancy Andrews.)

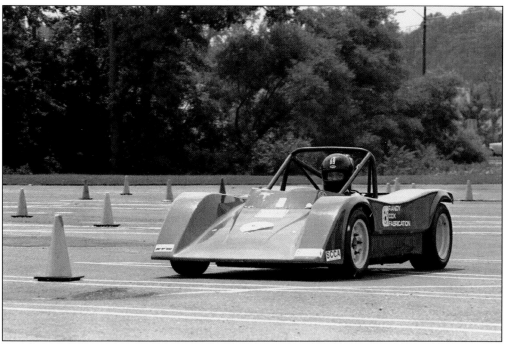

Lacking a real sponsor, many racers in smaller low-stakes events will often promote their business or the company they work for by placing impromptu logos on their cars. (*Charlotte Observer*, Nancy Andrews.)

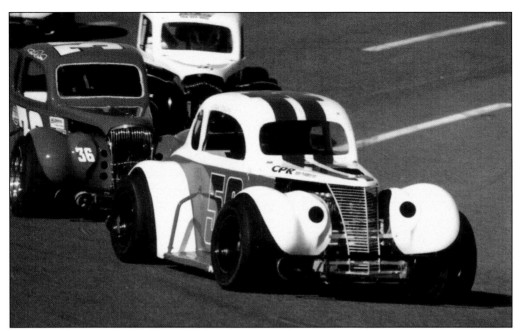

Since 1992, Legends Cars, born in Charlotte, have become immensely popular at tracks around the United States. Legends Cars were developed by Charlotte Motor Speedway officials, who realized that racing was becoming too expensive for the average person to participate. The cars are five-eighths scale fiberglass models of the modified pre-war cars that were driven on dirt tracks after World War II, have low maintenance costs, are simple to work on, and are lightweight so they can be towed by a pickup truck. They have caught on with fans and drivers all over the country, as they represent an effort to reclaim the roots of stock car racing. Concord Motorsport Park features Legends Cars on a regular basis. (Concord Motorsport Park.)

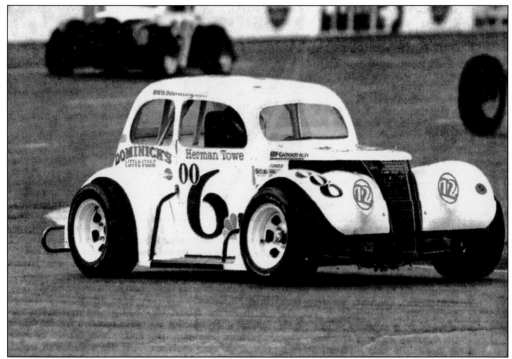

Herman Towe, a producer for a local television station, is one of the regulars on the Legends circuit. (*Charlotte Observer*, Christy Townsend.)

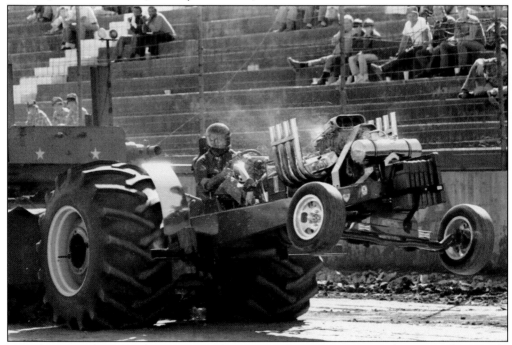

Metrolina Speedway was home to a wide variety of racing events. In this 1980 photograph, Bob Hutton drives his high-powered tractor in a tractor pull competition. (*Charlotte Observer*, Tom Franklin.)

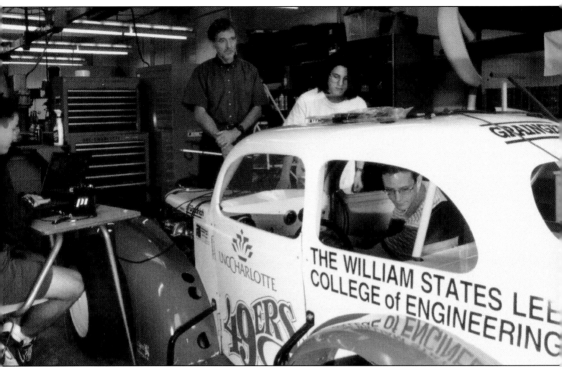

Located at the center of the automobile racing universe, the University of North Carolina at Charlotte's College of Engineering has developed a motorsports engineering program. Students learn the engineering aspects of motorsports, and even build and race their own cars. UNCC's race team won the intercollegiate championship four years in a row in the 1990s. (University of North Carolina at Charlotte.)

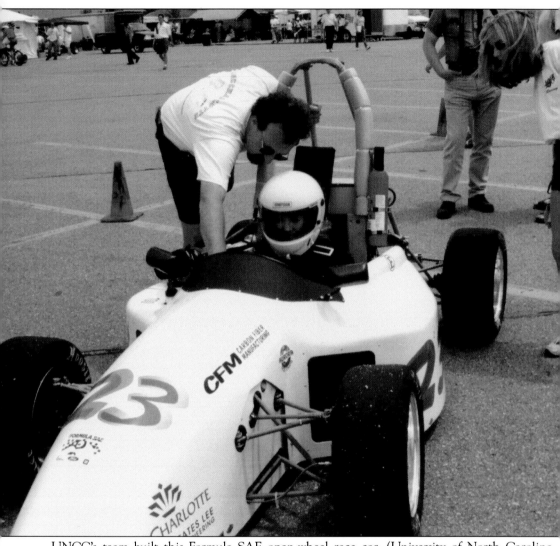

UNCC's team built this Formula SAE open-wheel race car. (University of North Carolina at Charlotte.)

Six

ALL-AMERICAN DREAMS
KID AUTO RACING

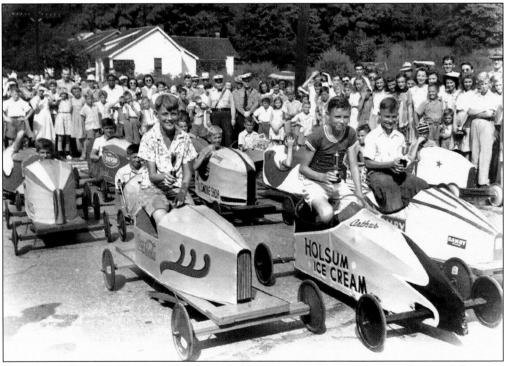

Founded in Dayton, Ohio in 1934, the All-American Soapbox Derby is still one of the most popular youth racing events in the world. Thousands of spectators turn out to cheer on the boys and girls who compete in over 250 cities around the country. Contestants must build their own cars, which are powered only by gravity. Here, the winners of the 1941 local derby in Salisbury pose with their trophies. The boy in the Holsum Ice Cream car is Arthur Mallory. On the far left is a young J. Newton Cohen, longtime Rowan County Commissioner and the winner of the local derby the following year. (*Salisbury Post.*)

Drew Hearn won the Charlotte Soapbox Derby in 1947 and later went on to be the race's longtime director. During his tenure as director, the city of Charlotte built a Derby Downs of its own, on Tyvola Road, where competitions drew contestants from all over the Carolinas. A cheating scandal at the National Derby led Mr. Hearn to pull the Charlotte race out of the National Soapbox Derby organization, which soon collapsed. Another group took its place, but the All-American Soapbox Derby had lost its luster, and Charlotte's Derby Downs closed a few years later. (Robinson-Spangler Carolina Room, Public Library of Charlotte and Mecklenburg County.)

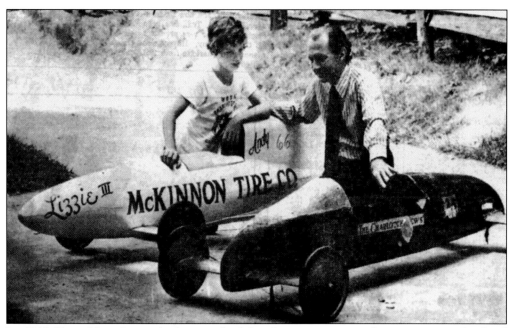

In 1966, Drew Hearn's son Andy won the Metrolina competition, for contestants who lived outside the city limits, at the All-American Soapbox Derby. Andy's car was named Lizzie after his father's car. (Robinson-Spangler Carolina Room, Public Library of Charlotte and Mecklenburg County.)

A proud young man polishes his soapbox entry in his driveway prior to the big race in 1960, which was held on Euclid Avenue in Charlotte. The *Charlotte News* long hosted the derby and snapped this photograph to promote the event. (Robinson-Spangler Carolina Room, Public Library of Charlotte and Mecklenburg County.)

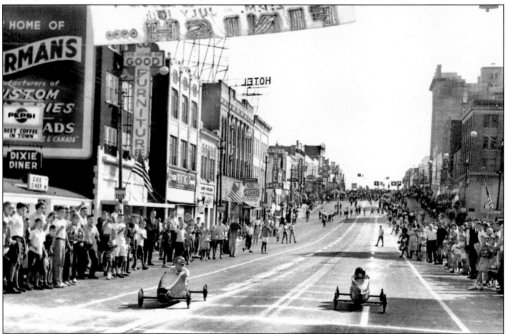

Dennis Campbell, left, ekes out a win over Jeff Vail at the finish line of the 1963 All-American Soapbox Derby regional finals at Liberty and North Main Streets in Salisbury. For his win, Dennis won a $500 savings bond and a trip to Derby Downs in Akron, Ohio for the national finals. (*Salisbury Post.*)

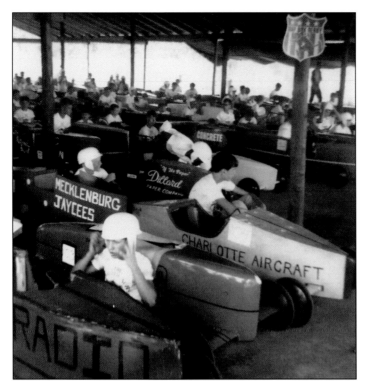

Contestants prepare for their first heats at the Optimist Derby Downs of Charlotte in 1966. For 47 of these boys, the race was over in less than 30 seconds. (Courtesy of Barry Dycus.)

Thirteen-year-old Bruce Dycus gets a kiss from a cheerleader after winning the Charlotte All-American Soapbox Derby in his Shark racer in 1966. Congratulating him on the left is Randall Norton of the *Charlotte News*. Over 130 boys entered the derby competition, and 8,000 people attended the races. (Courtesy of Barry Dycus.)

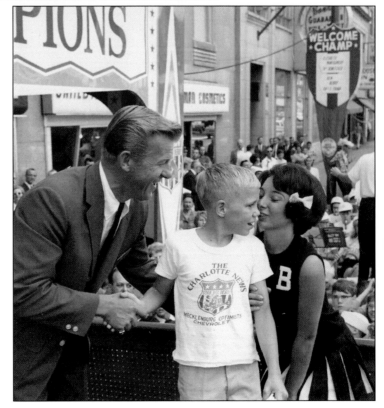

NASCAR driver Buddy Baker gives Jeff White, Charlotte's 1968 Soapbox Derby champ, a good luck jacket before he boards the plane to Akron to compete in the national derby finals. (Robinson-Spangler Carolina Room, Public Library of Charlotte and Mecklenburg County.)

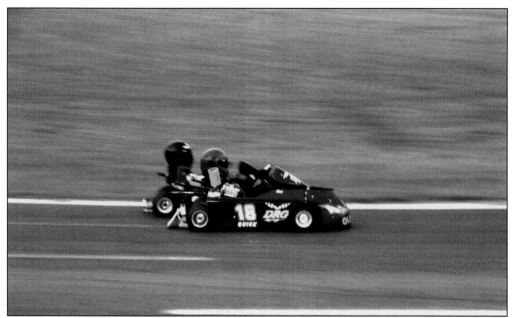

Since 1961, even the youngest kids could get involved in auto racing with go-karts. The World Karting Association, based in Charlotte, sanctions karting events in a range of classes, from Kid Karts for five- to seven-year-olds, up through seniors. Engines are usually 5 horsepower, but the lightweight cars can get up to 55 mph. These two boys are battling it out on the 1/4-mile track at Concord Motorsport Park. (Concord Motorsport Park.)

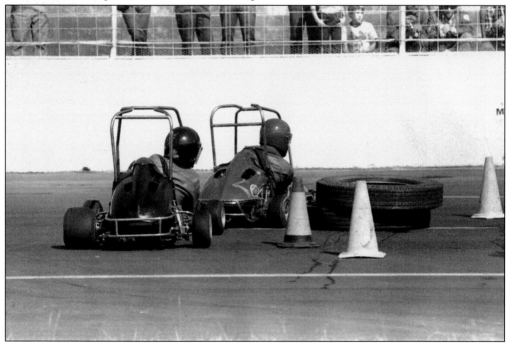

Pictured here are go-karts negotiating the course at Metrolina in 1980. Such famous drivers as Ricky Rudd, Rusty Wallace, Adam Petty, and John Andretti got their start racing in go-karts. (Robinson-Spangler Carolina Room, Public Library of Charlotte and Mecklenburg County.)

Slot cars appeared as early as the 1940s, running on tabletop tracks with miniature buildings and trees. By the 1960s, commercial slot car raceways had opened in cities across the country. These tracks required car operators to be skillful, lest their cars get bumped off the track by a "whoop-de-doo." By the late 1960s, slot cars had become too expensive for many youngsters to keep the hobby, though it's made a comeback in recent years. This 1965 photograph shows young slot car racers testing their nerves at a track in Kannapolis. (History Room, Charles A. Cannon Memorial Library, Kannapolis Branch.)

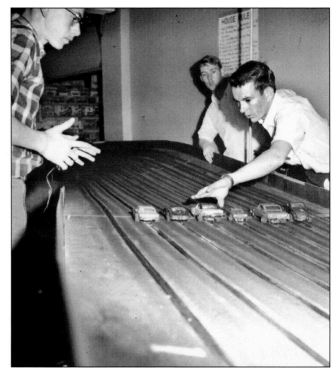

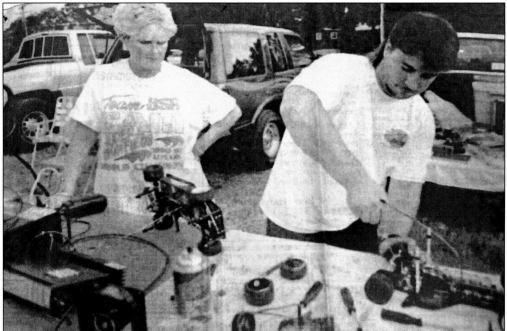

The Mid Carolina R/C Super Speedway, in Fort Mill, South Carolina, was designed to be a 1/10-scale miniature version of Charlotte Motor Speedway. The 15-inch-long remote controlled cars zoomed around the 385-foot track in competitions resembling what you might find at a full-scale speedway. They ran on batteries instead of gas, but otherwise, the cars were identical to stock cars. (Robinson-Spangler Carolina Room, Public Library of Charlotte and Mecklenburg County.)

ACKNOWLEDGMENTS

Several people and organizations made the research for this book a lot easier than it might have otherwise been. We would like to thank the *Charlotte Observer*, and especially Davie Hinshaw and Anne Bryant, for providing us with their assistance and allowing us access to their racing photographs. Frances Flock was very generous with her time and her scrapbooks. Steve Massengill of the North Carolina Office of Archives and History and Larry Thomas at Concord Motorsport Park gave us access to their photographs, as well as much helpful information about racing. The staff of the Robinson-Spangler Carolina Room at the Public Library of Charlotte and Mecklenburg County—especially Shelia Bumgarner, Pam Rasfeld, and Jane Johnson—took a great interest in the project and provided us with many useful sources. So did the staff at the Charles A. Cannon Library, Kannapolis Branch, including Larry Hayer, Norris Dearmon, and Terry Prather. Betty Carlan at the International Motorsports Hall of Fame provided expertise and was a good resource, especially on the dirt-track days. Gerry and Magaly Thalacker were very generous with their time, making their personal collection of photographs available to us and answering many questions on drag racing. Thanks also to Tom Hanchett and the staff at the Levine Museum of the New South, Charles Carpenter and John Clark, Dan Pierce at UNC-Asheville, Bob Coleman, Barry Dycus, Buz McKim at Daytona, Robin Brabham at the Atkins Library at the University of North Carolina at Charlotte, and Andy Mooney at the *Salisbury Post*.